D1037052

More than any art form, sculpture's primary concern is with the human image and natural form. The intimate association between the forward impulses of the sculptor and the limitations and possibilities of his materials—clay, stone, wood, metal, etc.—demands an extraordinary knowledge of technique and craft. It has often been said that great sculptors are the greatest artists; surely there are no works of art more beautiful than Michelangelo's David or the Venus de Milo. No art form is more difficult, none more rewarding.

Yet one need not be a great sculptor to enjoy sculpting; there are innumerable rewards and pleasures for the experienced amateur and for the neophyte. Arthur Zaidenberg, drawing on his years of experience in all forms of sculpture, here shows us *why* as well as how. It is virtually impossible to read this book and not be as enthusiastic about the craft of sculpting as its author.

Mr. Zaidenberg understands both modern and classic sculpture, and he gives examples of sculpture from the golden age of Greece to the graceful masterpieces of the twentieth century in order to prove to the reader the many forms sculpture can take, the many things it can say.

Yet this book is more than just a "sculpture appreciation" course. Mr. Zaidenberg discusses the various materials that can be used in sculpting, lists the advantages and disadvantages of each and, through pictures, shows us the finest examples of the use of the materials under discussion.

Discussed too are the different techniques of sculpting and the different tools the sculptor must use. In these sections, "how-to" photographs (often of the author himself at work) are used, and the result is pictorial and written advice of benefit to beginner and advanced student alike.

The New and Classic Sculpture Methods is a book for anyone who has ever worked with clay or metal or wood or stone or precious stones or glass—or any material at all that can be shaped into a work of art. Its enthusiasm is infectious; its advice is completely sound. It is a labor of love about what may be the highest art form of all.

Arthur Zaidenberg, himself a nationally known painter and sculptor, is the author of many books on the arts, among them *The Painting of Pictures* and *Drawing All Animals*. He and his wife spend half the year in Mexico, the other half in New York State.

The new and classic
sculpture methods

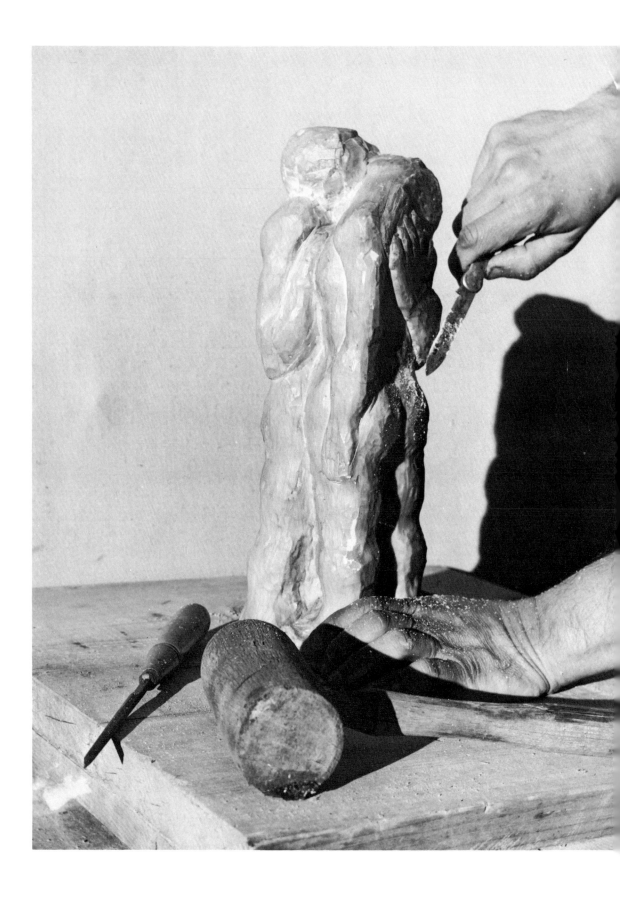

Arthur Zaidenberg

The new and classic sculpture methods

Drawings by the author

WORLD PUBLISHING
TIMES MIRROR
NEW YORK

Published by THE WORLD PUBLISHING COMPANY

Published simultaneously in Canada by NELSON, FOSTER & SCOTT LTD.

First printing–1972

Copyright © 1972 by Arthur Zaidenberg

*All rights reserved. No part of this book may be reproduced
in any form without written permission from the publisher,
except for brief passages included in a review appearing
in a newspaper or magazine.*

ISBN 0–529–00289–2
Library of Congress catalog card number 68–15190
PRINTED IN THE UNITED STATES OF AMERICA

WORLD PUBLISHING
TIMES MIRROR

Contents

Foreword

I would like to preface this book by issuing a warning against "experts" on sculpture. That may sound odd, to say the least, coming from the author of a book about the technical processes involved in sculpture. Supposedly he should know all about his subject and provide that total information to his reader.

Alas, it must be confessed that this author does not know everything about all the technicalities of the sculptor's craft and that even such knowledge as he does have is subject to challenge by those who are more experienced and who are specialists in the various branches of sculpture discussed in these pages.

Such advice as is contained here has been subject to the criterion that pervades all the books of art instruction I have written. Of necessity this criterion is the only reliable critical approach in teaching so unscientific and inexact a subject as art. That critical approach is "Has it worked for me?"

My observations and questioning have confirmed in me the belief that no two sculptors work alike, in terms either of technique or of methods of application of that technique. Furthermore, research shows that the "experts" who have written large tomes on the technical processes involved in the use of materials, their mixtures and proportions, have differed so much from one another that they have evidently used the same trial-and-error approach that I have used.

The information in this book is designed to lead the beginning sculptor to start his voyage into the only roughly charted seas of the materials and processes of sculpture. The major purpose is to remove his fears of the unknown and to assure the tyro sculptor that, aside from a few fundamental do's and don't's, there are no fast rules and he may sail off independently on his own discoveries as soon as he wishes, quite as safely as any "professional."

The resultant discoveries for both are unpredictable in quality, but the pleasure to be found in the adventure is certain.

Arthur Zaidenberg

Introduction

Sculpture is perhaps the most natural of the arts. Primitive people before recorded history saw shapes in the rocks and trees around them and with crude cutting tools brought those shapes to life for others to see.

The three-dimensional character of carved objects called for none of the subtle, abstract concepts that were required of the primitive painter, who had to "translate" his visions into two-dimensional pictures.

The basic materials for sculpture were available to ancient man in limitless quantity. No special ingenuity was required to produce them such as was needed for the pigments for painting.

He discovered the modeling qualities of clay through imprints in the mud. Wood writhed into forms ready to be torn from the trees and driftwood evoked images. Water and wind carved and polished stones that asked only for the refinements of man's imagination applied with simple tools.

The cutting tools that he used were the same as those he fashioned for defending himself and hunting and for chopping firewood and building shelters.

The bones and tusks remaining from his hunts and feasts lent themselves readily to whittling into images evoked by his primitive emotions.

It is extremely rare to find a primitive people — prehistoric, ancient, or contemporary — who have not developed some form of sculpture.

As man's inventiveness produced better tools and man's imagination soared with civilization, his artistic concepts became more elaborate and he no longer relied entirely on what lay close at hand. Fine materials — especially quarried marble, granites, and many other beautiful stones — were sought for and transported laboriously to the sculptors who carved on communal projects — temples, palaces, and monuments.

When such splendid works as these began to be built, there evolved a tendency away from the individual craftsman-artist working in his cave or hut for his own personal expression, and, with many notable exceptions, the art of sculpture became an adjunct to architecture, part of a collective effort.

Painting remained, for the most part, the province of the individualist, anxious to express his own vision, possibly because it did not lend itself so obviously to the glorification of the gods and heroes. While the centuries produced hundreds of sculptors whose names are known to the world, the same period of time produced thousands of painters.

An additional reason for the disparity in numbers between painters and sculptors may very well have been that, with the growth of city living, the natural materials of the sculptor no longer lay freely about him. The cost of materials and the requirements of space became factors to be reckoned with.

It is only in very recent years that there has been a great reawakening in interest in sculpture. This must be attributed to the liberation of all the arts by "modern" concepts, which have brought freedom of imagination and daring departures from convention and tradition in the choice of materials used.

The sculptor of today may use countless materials that the sculptor of twenty-five years ago would not have dreamed of as being appropriate for his purposes.

Permanence of material, guaranteeing survival through the ages, is no longer a requirement. Traditional stone, wood, clay, ivory, bone, and bronze have given way, in many instances of unusual but nonetheless valid artistic expression, to glass, plastics, burlap, paper, wire, and innumerable other materials and combinations of materials.

Sculpture may swing, swivel, move by motors, twinkle with electric lights, and even be self-destructive, blowing up or decomposing before the viewer.

Modern sculptors have worked the new materials with modern electrical tools. These help them weld, solder, extrude, and shape heavy metals.

Modern sculptors have devised giant sunbursts of gleaming wire, twisted heavy gauge metal into fantastic shapes, joined heavy, uncut stones into fascinating structures with powerful epoxy glues, made kinetic mobiles driven by transistorized motors, and welded huge steel abstractions with fast-action modern electric welding tools.

It is in sculpture perhaps more than in painting that the daring abstract concept is successful.

The powerful structures in steel by the late David Smith or the dancing mobiles of Alexander Calder seem reasonable extensions of the rocky cliffs or waving branches of nature, more readily acceptable than similar nonobjective statements on canvas.

Henry Moore's convoluted and penetrated stone monoliths and Giacometti's elongated, impersonal metal creatures easily live well with nature's many-faceted boulders or the inventive shapes of roots and stalagmites or the brilliance of icicles.

Much pomposity has gone out of sculpture, and although many of the new works are fad-inspired and exhibitionist trash, some are brilliant and exciting, evoking responses as intense as any of the classics in sculpture.

The best result of the liberation of sculptors from tradition in material and form of expression is that thousands of talents have emerged, many of them revealing to us a wit and vision that justify themselves.

The public's interest in sculpture and in sculpting has grown enormously in recent years — so much so that sculpture, which has long been subordinated to the art of painting in the number of its practitioners and its audiences, can be said to be entering a real period of renaissance.

Lack of adequate working space and the forbidding nature of the materials and tools of classic sculpture have acted as deterrents to the amateur and student.

But because of the increased number of people who are moving to roomier, suburban homes, the trend toward clutter-free apartments, and the proliferation of museums and galleries, sculpture is finding new breathing space.

It is the intention of this book to introduce to the amateur and student many of the new materials, tools, and viewpoints in modern sculpture as well as to reduce to simple terms the classic methods of the sculpture of the past and to remove some of their more forbidding character.

The book is addressed primarily to the sculpture student and the beginner but it is the author's hope that it will evoke sufficient curiosity in the hobbyist to lead him into the adventure that is sculpture.

What is sculpture?

Even though the word sculpture is derived from the Latin *sculpere* meaning "to cut from stone," it may now be applied to any three-dimensional form fashioned, modeled, constructed, or contrived in any material as an object conceived for esthetic expression.

Entering into this artistic expression are considerations of space, texture, masses, planes, movement, light and shade, balance, and — most important — emotional expression, the "idea" that the artist has to convey.

If the above definition is acceptable (probably no definition could be inclusive enough to encompass every sculptor's concept), you can see that the leeway for expression is extremely wide. Its only limitations are the imagination and the materials available.

Many of the most modern concepts may shock the lover of conventional sculpture, but they are tributes to the ranging imagination of our times. Amid the still valid sculptural expressions being created in classic materials and in relatively conventional styles are to be found many daring sculptural statements evocative of the soaring sciences and daring philosophies of our tumultuous era.

As we have said, the art of sculpture embraces a wide field of creative procedures using innumerable materials and techniques — all the creative processes, in fact, that involve work in three-dimensional masses. In a sense this includes architecture or the production of any man-made structure. The exquisite pieces of furniture in Tutankhamen's burial chamber were sculptural objects of high quality. The chairs of contemporary designers very often have worth as sculptured forms quite aside from their utilitarian value.

The Museum of Modern Art in New York has exhibited kitchen utensils and appliances of high sculptural merit. Ball bearings, gears, and other elements of our complex machines are beautiful objects because of their absolute purity of design and the beauty of the metals used. The industrial designer

is often as truly an artist as the "fine art" sculptor in his uncommercial studio.

Brilliant contemporary sculptors have frequently welded a variety of these machine parts and tools together to form striking works of art. Wooden chair legs, doorknobs, boxes, and countless other everyday objects have been glued together by inventive artists to contrive witty, inspired works.

In short, the sculptor has at his command a range of materials and a liberty of inventiveness far greater than are available to the painter. There are no boundaries save those of his imagination and taste.

Choice of subject matter

The limits imposed on the sculptor's choice of subject matter by the inevitably solid nature of his materials are not as stringent as they might at first appear to be.

To attempt to depict air or landscapes or water in any terms but symbolic ones would strain the nature of the sculpture process. Fortunately, few sculptors wish to work literally on such subject matter.

Though colors may be added to the natural color of clay, wood, steel, or any of the other sculptural media, the subtleties possible in direct painting are necessarily lacking.

On the other hand, the human body and the bodies of animals can, of course, be given better expression in realistic terms through sculpture than is possible in a painting.

Abstract forms are actual in sculpture because one is dealing in form rather than simulating it. In abstract sculpture, space and light are real and are part of the sculptor's medium. He may make those elements part of his working material.

Subject matter is all about us, ready for the sculptor's appropriation. Not only are people and animals of interest to the sculptor but also inanimate objects, man-made or natural. All form invites the artist to paraphrase, modify or exaggerate, symbolize or abstract.

But remember that it is quite contrary to the purpose or the character of an artist's work to attempt to re-create exactly in painstaking detail a perfect copy of a natural object or a living being. Sculpture is as pure a "fine art" as is available to the artist. Leave such copying to the taxidermist.

Space

The shape of the space immediately around a piece of sculpture is almost as important as the shape of the piece itself.

The line of a line drawing that creates the suggestion of a figure *within* its boundaries also suggests space on the *outside* of its boundaries, and that space must be of artistic merit or the image is injured.

A sculptor works with air as well as with the actual medium. True, his work area is not like the confines of a rectangular canvas, but he must still consider the space in juxtaposition with the elements of his sculpture, for his piece like that of the painter becomes a "composition" by the inclusion of the surrounding space.

Henry Moore, the great English sculptor, carves many of his figures with large holes of empty space *within* the confines of the piece. These are very much a part of the sculpture. They add a dimension that the normal concavities and protuberances of the "realistic" piece cannot convey.

In a number of bronzes, the late Italian sculptor Giacometti grouped several of his elongated figures on a plane of bronze in carefully spaced positions and heights in relation to each other.

Michelangelo's pronouncement that a sound sculpture should be able to roll down a mountain unhindered by protruding forms on its surface is much too arbitrary and restrictive of the exploitation of the beauty of space around and within a piece of sculpture.

Fortunately he did not follow his own axiom in many of his own great works.

Elongated figures typical of Giacometti's vision. They live on a rough, flat plane of bronze.

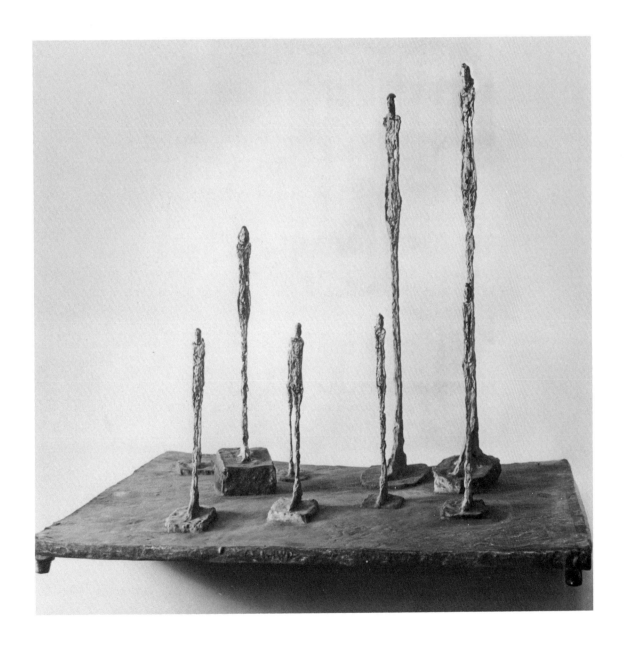

17

The great pyramid of Cheops with the Sphinx in the foreground.

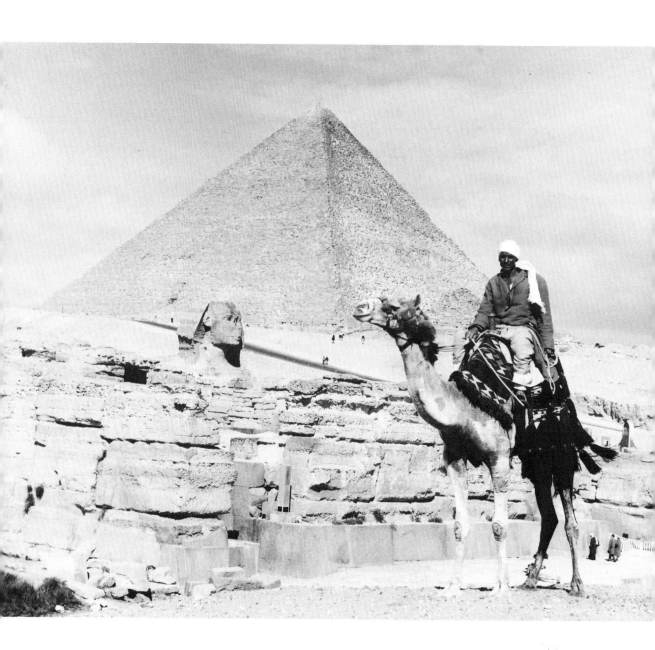

Forms and masses

The essential forms in nature are the sphere, the cube, the pyramid, and the cone. All other forms are variations of these basic ones.

The variations may be extreme but the source form is always discernible.

These essential, three-dimensional geometric forms are all that the sculptor has to work with, but they are enough.

Very much like the eight notes in the musical scale the combinations are infinite. Sublime music can be made from that scale. Similarly, sublime beauty can be created by an arrangement of the geometric essentials.

The departures from the four classic forms — sphere, cube, pyramid, and cone — need not be very drastic to achieve great sculptural beauty.

Look at the compelling power and serenity of the Egyptian pyramid shown here. The sphinx head seems fussy and unimportant by comparison.

Now look at the simple grandeur of the Parthenon. Its lovely forms even in ruins convey the noble inspiration of its sculptor-architect, who found in basic geometrics the qualities needed for his lofty concept.

The next picture, the beautiful Taj Mahal, is another example of ethereal beauty achieved with uncomplicated form. The delicate traceries of its jeweled inlays and carved marbles are incidental to the exquisite "rightness" of its basic structural forms.

Many modern sculptors are bold enough to appropriate objects of absolutely unbroken geometric purity as they come from the foundry and exhibit them unaltered as sculpture. The exhibitor's claim to being the "sculptor" is that it was he who recognized the form's beauty. However, the experimental sculptor need not resort to such austerity.

Departure from the rigidity imposed by restriction to the unvaried form is not a law of esthetics for the sculptor. But — and this may well be considered an esthetic law — the search to reduce forms to their simplest components in the telling of the sculptural story is inevitably valid. Such simplification can make the difference between the sculpturesque and the picayune.

The Parthenon, the Doric Temple of Athena built in the fifth century B.C.

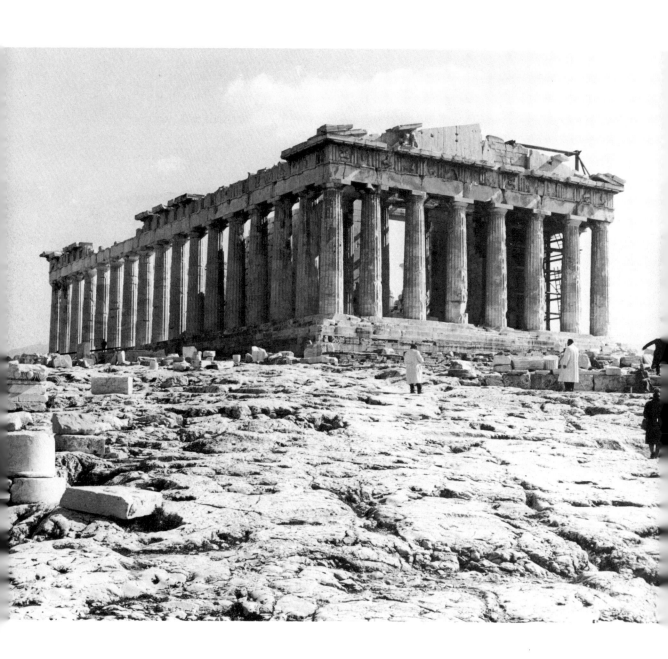

The Taj Mahal at Agra, India, built 1632-1645.

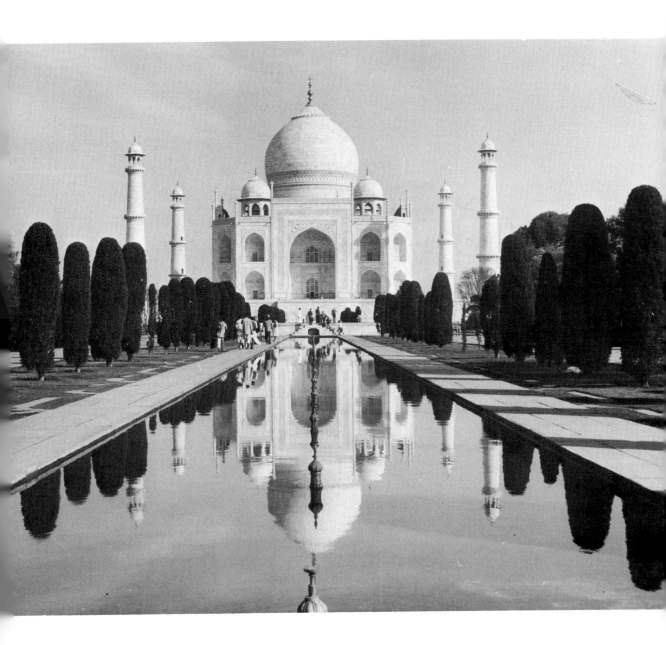

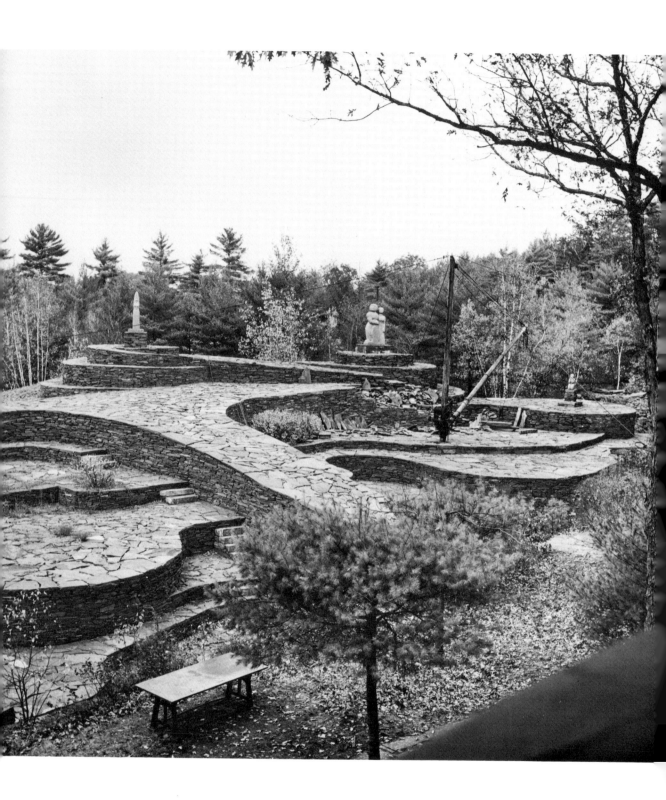

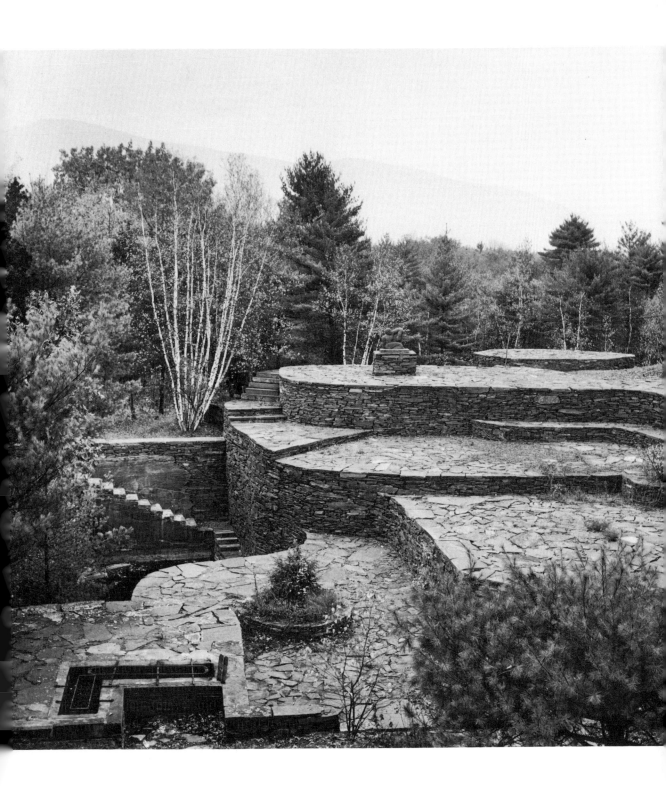

This vista of stone construction by the sculptor Harvey Fite is a monumental project in abstract, geometric sculpture. The work of one artist over a period of twenty years, it is still in progress.

Here are the basic geometric shapes and some of the variations derived from them.

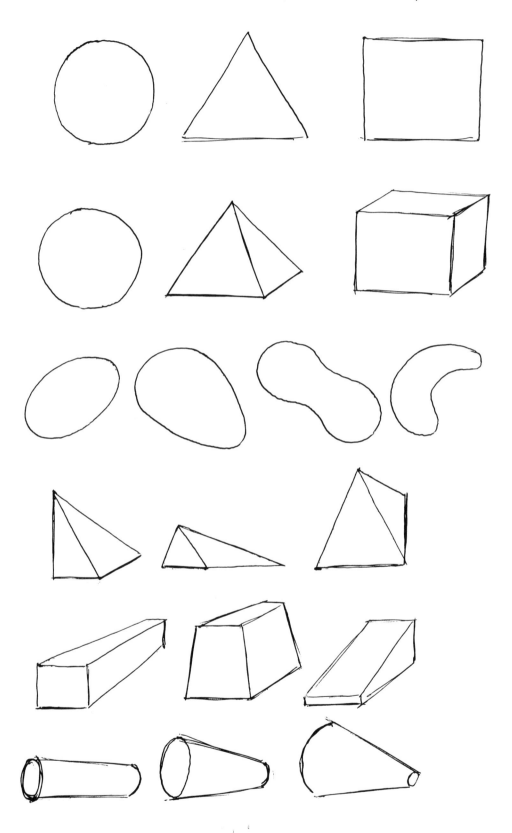

The shading conveys the impression of three-dimensional form.

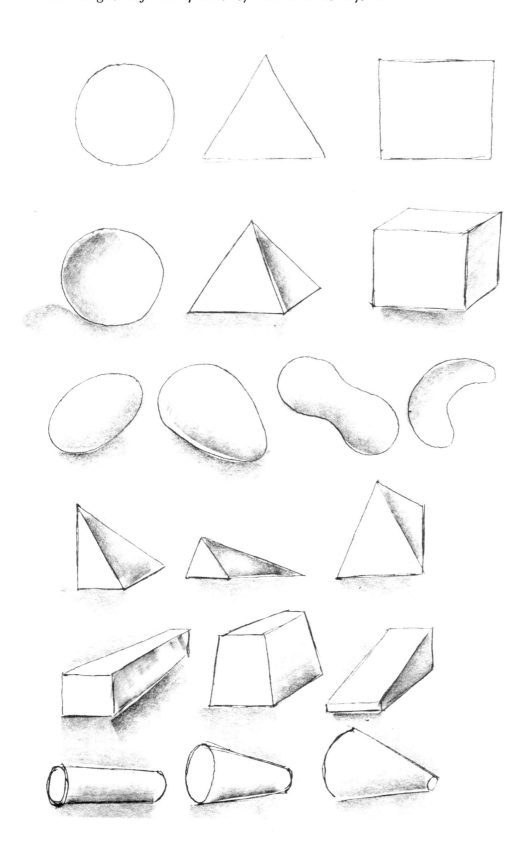

The combination of geometric forms on paper should be a preliminary "game" before actual modeling begins.

A basic geometric figure analysis.

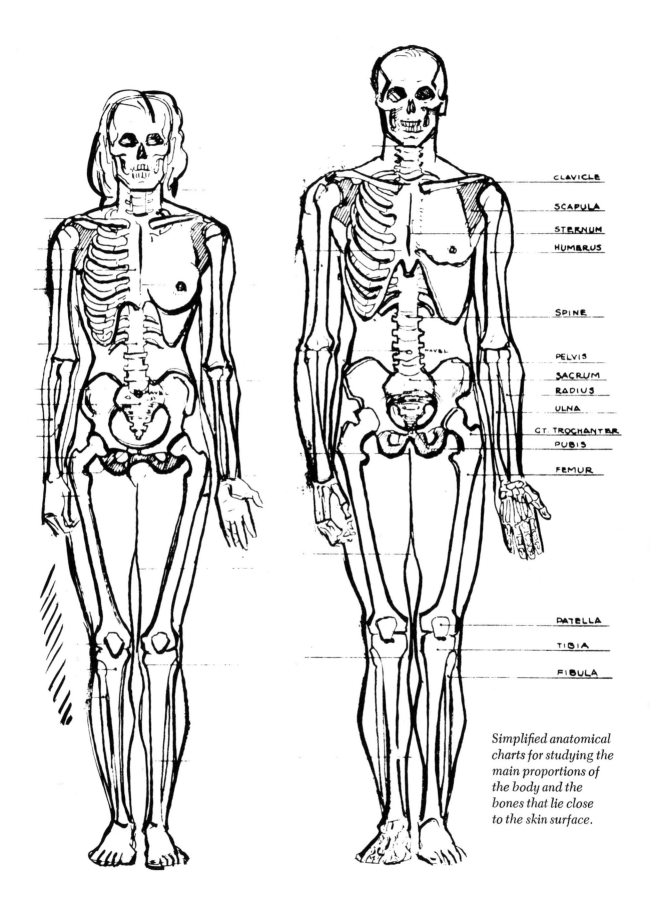

CLAVICLE

SCAPULA

STERNUM

HUMERUS

SPINE

PELVIS

SACRUM

RADIUS

ULNA

GT. TROCHANTER

PUBIS

FEMUR

PATELLA

TIBIA

FIBULA

NAVEL

Simplified anatomical charts for studying the main proportions of the body and the bones that lie close to the skin surface.

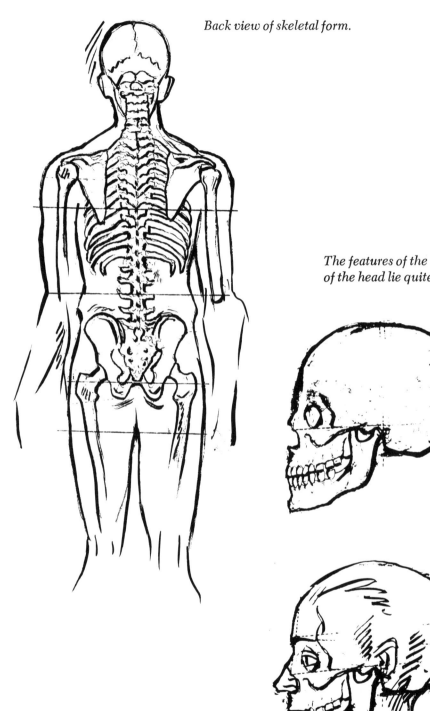

Back view of skeletal form.

The features of the face and the outer contours of the head lie quite close to the bone structure of the skull.

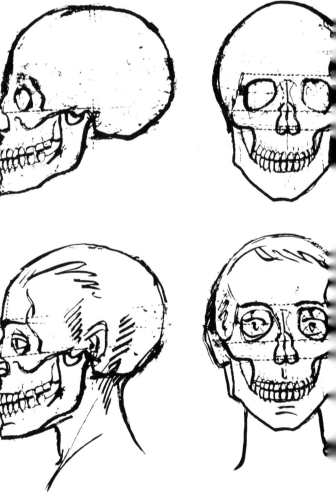

Drawing for sculpture

A sculptor need not be a fine draftsman in the *academic* sense of that word. A highly developed ability to draw is a fine accomplishment, but it is not indispensable to the sculptor.

However, most good sculptors do draw very well, and there have been few who could not make fine, strong drawings of their projected sculptural works. These drawings usually have "sculpturesque" qualities. That is, they suggest the three dimensional, because this is the ultimate objective in the mind of the artist. He makes these drawings as preliminary studies in the analysis of the forms, not as an end product.

The importance of drawing for sculpture cannot be minimized. Like the architect's plans and the cabinet maker's working drawings, sculptors' drawings are necessary preliminaries. These drawings must be of the special nature required as "visuals" for the sculpture to come.

To aid you in making sculpture studies, this section of the book contains drawings to serve as examples of the study of forms made with the eventual sculpted product in mind.

When the student has acquired an ability to draw simple sculptural drawings, he may make his preliminary studies on paper or draw directly on the surface of the material to be carved. These simple form drawings will act as guide lines for cutting, but more than that, they will help keep alive the original concept — the realization of which is often lost in the long process of roughing-out the contours on a stone or wood piece or in the building-up process in the modeling media.

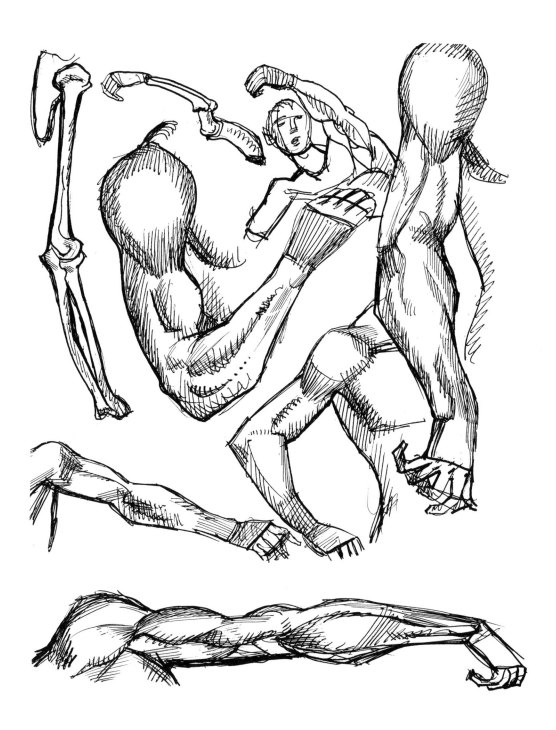

Figures drawn as plans for ultimate sculpture figures. Notice how the planes are indicated to help visualize the three-dimensional nature of sculpture.

Blocking out the drawing for study of sculptural forms.

Tools

When one considers the brilliant sculpture created by technologically primitive people thousands of years ago, one must admit that the quality and variety of the tools of the craft must be of secondary importance.

Artists have very commonly had to get along in spite of a lack of cash and a scarcity of skilled toolmakers in many parts of the world — and not only in primitive places or periods. Their drive to create and their natural ingenuity and inventiveness have always managed to overcome such relatively small obstacles.

Although the contemporary artist is generally somewhat better off financially than were many of his predecessors, with a few notable exceptions, he still is not at a level of affluence comparable to that of most other professions.

Fortunately, when specially prepared, finely tempered steel tools are not available to the sculptor, secondhand chisels, rasps, and hammers of the humble quarrystone-cutter may still be found in junk shops.

Carpenters' wood chisels are inexpensive and are suitable for most wood-carving purposes.

A clay modeler I knew made beautiful sculpture with spoon handles, which he bent to suit his purposes.

The above is not intended as disparagement of the excellent equipment sold by sculptors' supply shops. There are enough problems for the artist to cope with without the addition of irritatingly inadequate work tools. If fine equipment is available where you live and you have the money to buy it, by all means avail yourself of it as much as you can.

But one must not put off the pleasures of sculpture for lack of the many splendid but dispensable tools of the professional sculptor.

The tools of the ancient Egyptian stone-cutter. The metal blades were bronze.

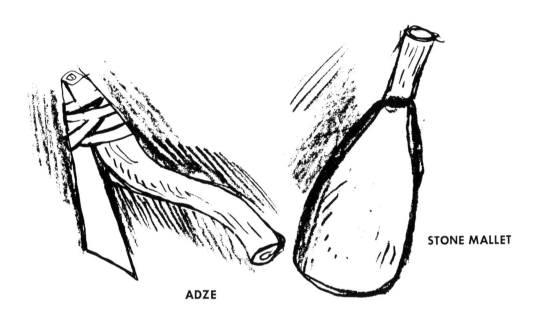

ADZE

STONE MALLET

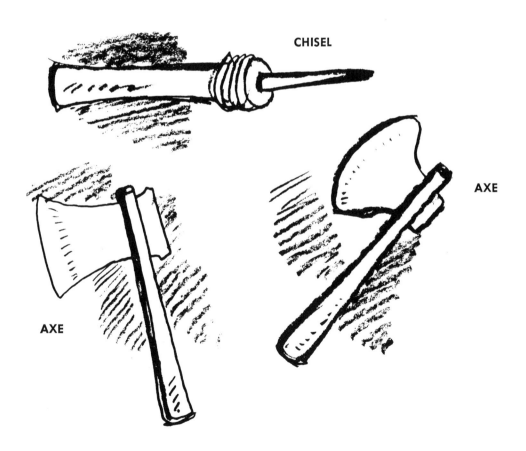

CHISEL

AXE

AXE

Modeling

Modeling is the process of building up, in pliant materials, the structure of a piece of sculpture.

It is the "easier" of the two methods of creating sculpture. This does not imply that it is the least bit less valid or important than the carving method.

It is in the ultimate realization of the concept that the virtue of a piece of sculpture lies — not in the material or method used.

It cannot be stressed too often that the amount of sweat and muscle contributed to a work of art is relevant only insofar as it may detract from the work, and that the most direct effort to accomplish one's purpose with a minimum of wasted energy is the most desirable one. Excessive pain in the process of achieving the set goal will show in the final accomplishment, to its detriment. Spontaneity and vitality are often lost in the agony of unnecessary toil.

The relative durability of the materials used in the carving methods is balanced by the excellent methods that have been developed for casting in metal from the fragile clays and for the firing of terra cottas. Welding and soldering methods have brought about direct metal sculpture, which is as durable as carved stone and hard wood.

The great sculptors of the past used both methods, and it is doubtful whether they honored one method more than the other. If we are to choose one method instead of another, the choice should be based on the suitability of both the material and method to the special theme to be expressed. The choice of clay may be based on a need to capture a feeling, to transfer it with a minimum of material interference between the inspiration and the realization. The finger-contact in the telling of that "story" in clay is registered and imparts to the modeled figure the quality of immediacy characteristic of the pencil sketch.

This is not to imply that one may not work long and carefully in clay to produce massive concepts, or that clay is merely a sketching medium. Its versatility is great. Let us examine the classic approaches to modeling in clay.

Our first consideration must be the nature of that material. Clay is a direct product of the earth, ready in its natural form for the hand of the sculptor. Mixed with water it is pliant and malleable. When it dries it is ready for casting in more lasting material or for firing in a kiln or oven. It then may be sufficiently durable to last hundreds or even thousands of years if given no more than ordinary protection from excessive violence.

There are many clays. Some are more suited to firing than others. The artists' supply shops have made available to us a variety of them, some suitable for casting, others for firing, and even some of a self-hardening character that makes them quite durable without any special treatment.

These various commercial products have been processed with the addition of fine sand and moisturizing substances to preserve them in their packaged state so that they are yielding and plastic when used.

Clays are available in a number of colors of gray, blue, brown, and green. They are darker when wet than when they have dried. Firing in a kiln will often change the original color. In addition, coloring agents of a great variety may be added to produce, in the firing process, beautiful glazes of great luminosity and translucency.

For student practice, plasteline is ideal because it is permanently pliable and reusable. It may be bought for about seventy-five cents per pound, which is considerably more expensive than clay, but its continuing usefulness for practice purposes makes it worthwhile.

Modeling tools

Wire-ended tools are used for cutting away masses of the clay during the rougher stages of modeling the figure.

Wooden tools are used in shaping detail and for smoothing. They vary greatly in shape and size. A reasonably varied assortment should be acquired.

Most of the modeling process is done with the fingers. The application of the pellets or "worms" of clay requires a direct contact that cannot be established by any tool ever contrived. The thumb and first finger are your best modeling tools.

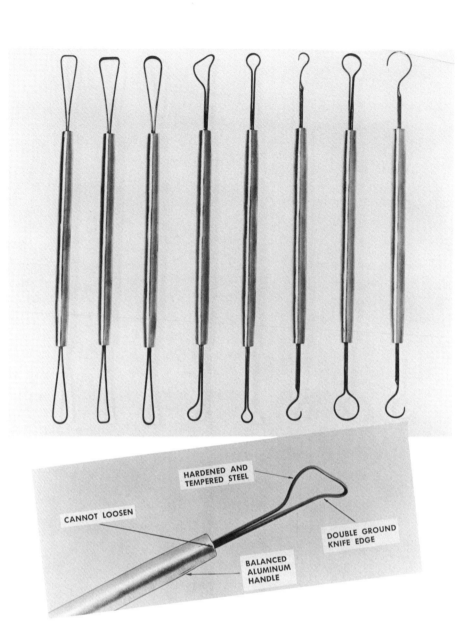

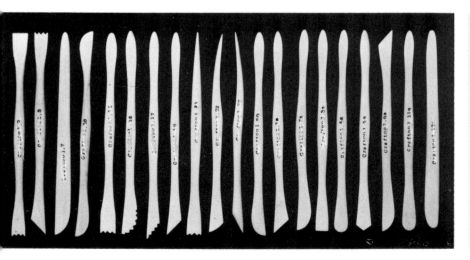

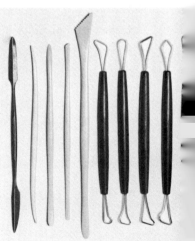

The pliant nature of clay requires that a "skeleton," or armature of some rigid material, be used as an understructure to support the masses of soft clay as they are built up to the required forms. These rigid supports remain within the figure, disappearing from view as they are covered by the thick clay.

Here are shown some typical armatures commonly used by sculptors for heads and figures. It must be pointed out, however, that each variety of subject to be modeled will call for its own special shape of armature. Every jutting part and unbalanced mass will need its own wire or pipe or wooden inner support.

For complex pieces of sculpture in clay, flexible wire of strengths commensurate with the size and weight of the planned pieces may be used, along with lead pipe, tubing, wire mesh, and lengths of wood. Relatively simple structures are needed for most simple standing pieces.

The armature does not need to be such a complex sculpture in itself that it almost resembles the finished piece except for the addition of a "skin" of clay. Just enough armature is needed to follow the basic movements of the main forms and the jutting areas of action.

Opposite: Bottom left, wooden modeling tools used for shaping and compressing clay forms.

Bottom right, metal-end modeling tools used for scraping and removing excess clay.

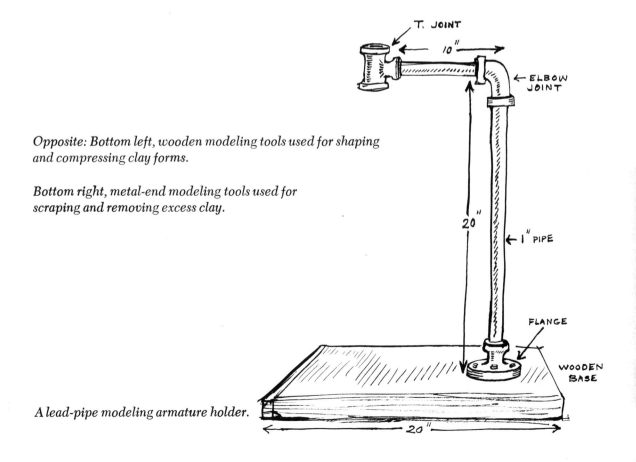

A lead-pipe modeling armature holder.

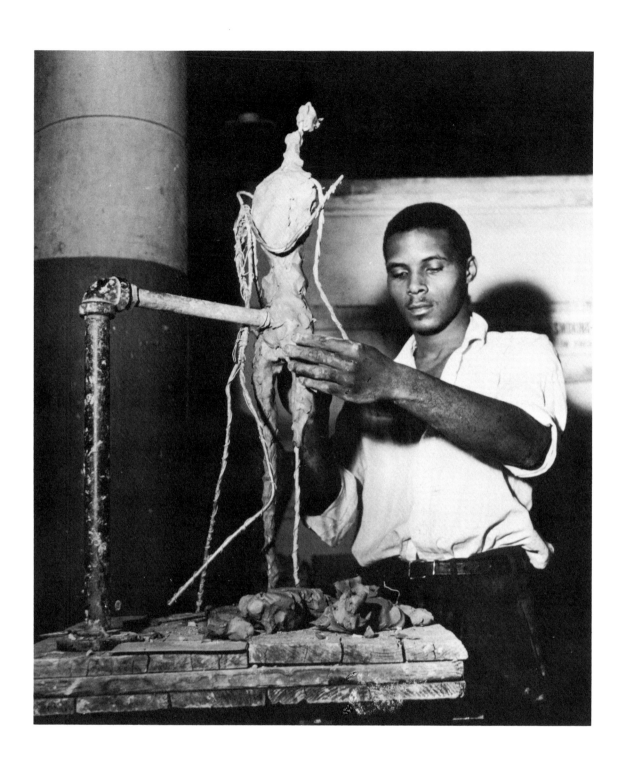

Student at work using pipe modeling armature.

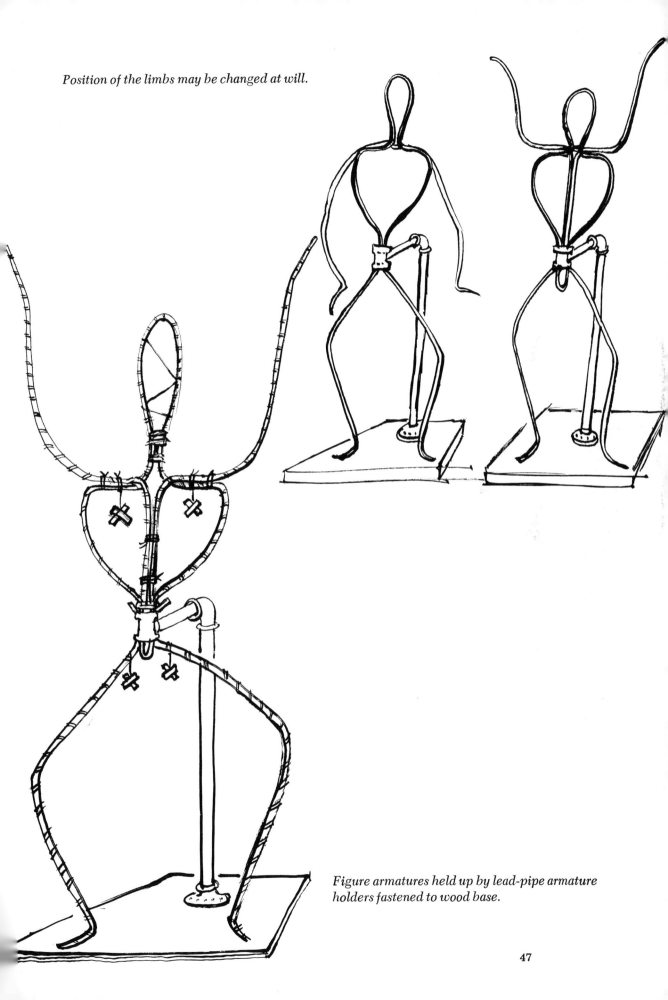

Position of the limbs may be changed at will.

Figure armatures held up by lead-pipe armature holders fastened to wood base.

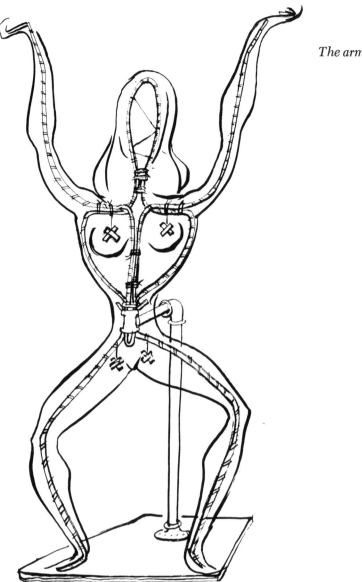

The armature covered with clay.

For small compact pieces of sculpture intended for firing in the kiln, armatures are not advisable. The clay must be packed firmly together, and interior air holes must be eliminated. For larger pieces a hollow core must remain within to allow for contraction under heat.

For large pieces of sculpture, wire or soft lead pipes are inadequate and armatures are often made of rods of steel or heavy-gauge aluminum.

In rounded heavy masses of clay, such as heads or busts, sculptors often use "butterflies." These are made of crossed pieces of wood wired together and hung from parts of the armature. They act to support the clay, preventing sagging and slipping.

The armature holder is dismantled when the figure has hardened and the wire armature remains within.

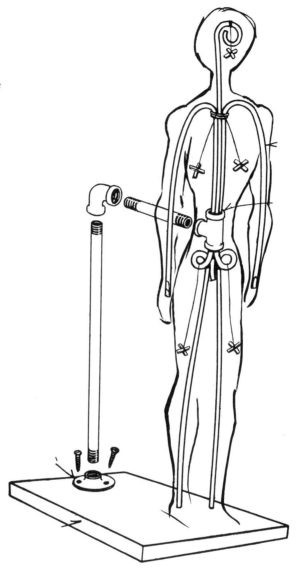

The clay packing that is immediately in contact with the armature should be somewhat drier than the regular working clay and should be packed quite firmly around the parts of the armature. As the work progresses, the density of the clay applied need not be as great because clay adheres to clay considerably better than to the metal of the armature. The clay should be applied in small moist pellets kneaded to relatively uniform size for the building-up process.

With the armature completely covered, the actual modeling procedure follows — and you can be secure in the knowledge that your work will not collapse before your eyes.

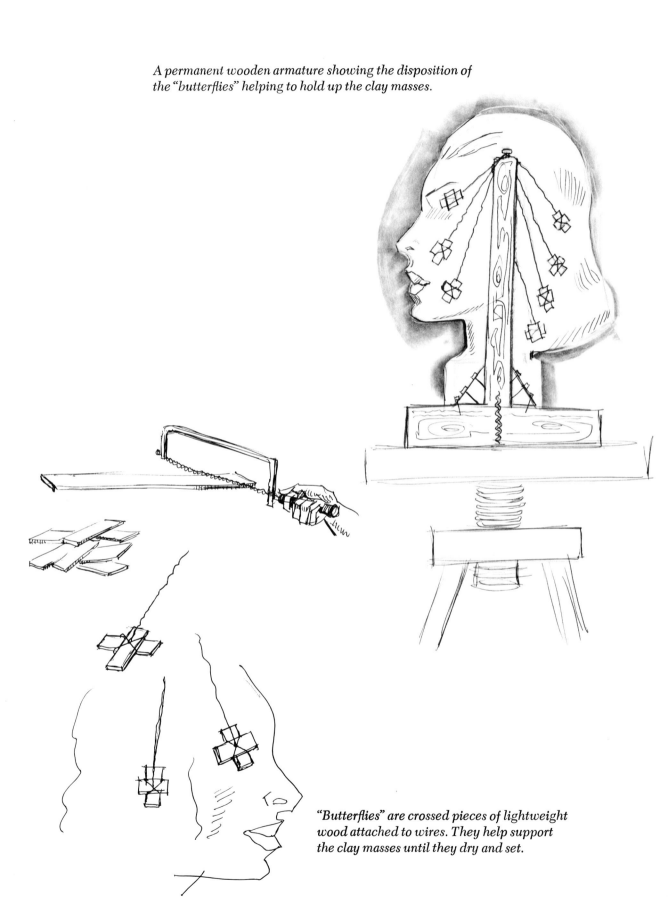

A permanent wooden armature showing the disposition of the "butterflies" helping to hold up the clay masses.

"Butterflies" are crossed pieces of lightweight wood attached to wires. They help support the clay masses until they dry and set.

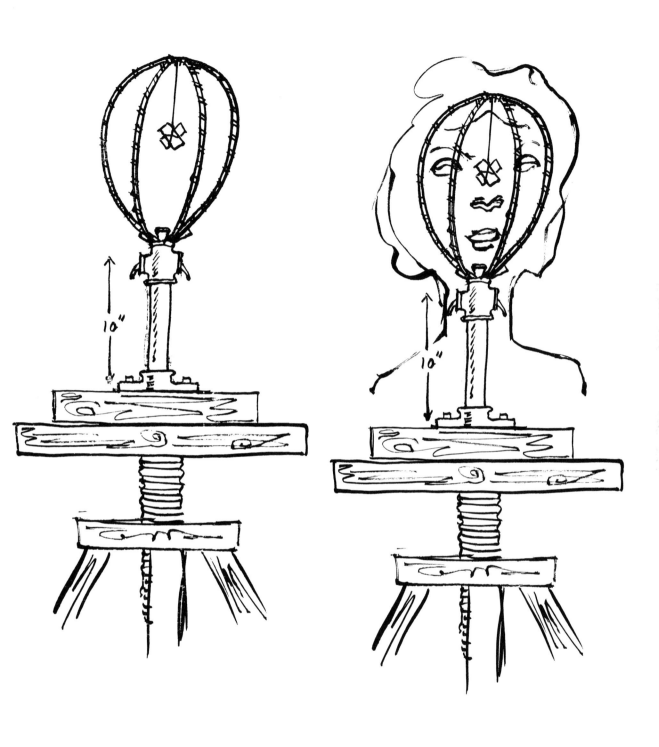

*A football-shaped wire armature within a head is used
as a support for the masses of clay.*

08528

51

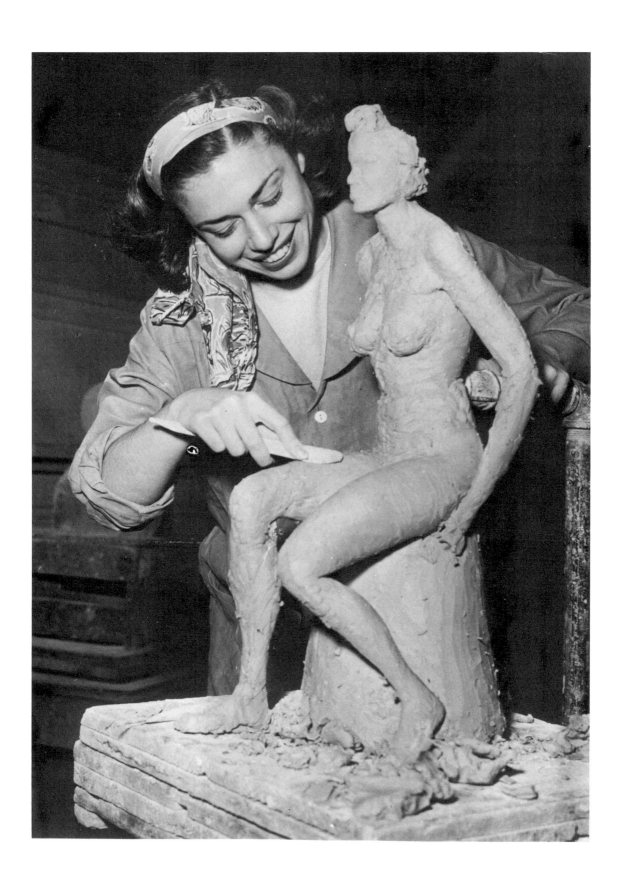

Clay figures entirely supported by an internal armature without lead-pipe holders.

Opposite: The figure is still attached to the lead-pipe armature holder while a student shapes the form.

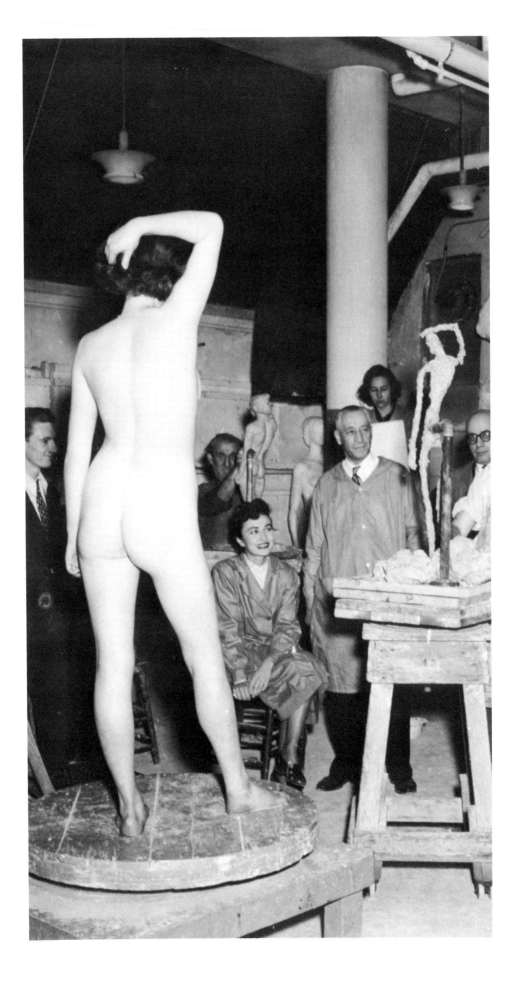

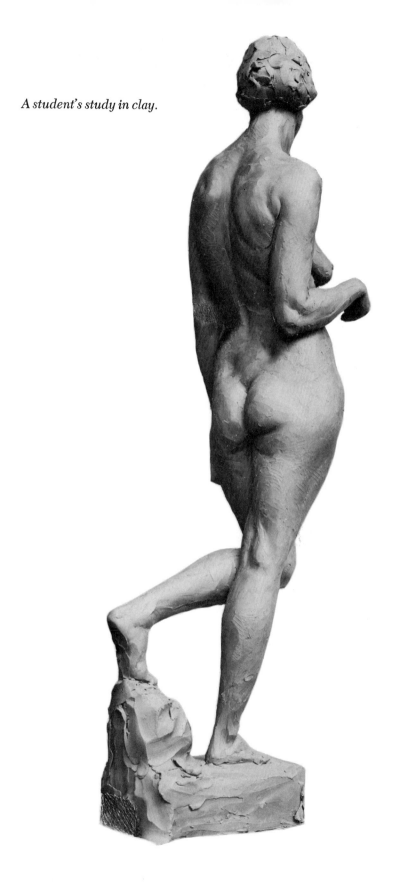

A student's study in clay.

*Opposite: A typical modeling class
using a live model.*

55

Another clay study.

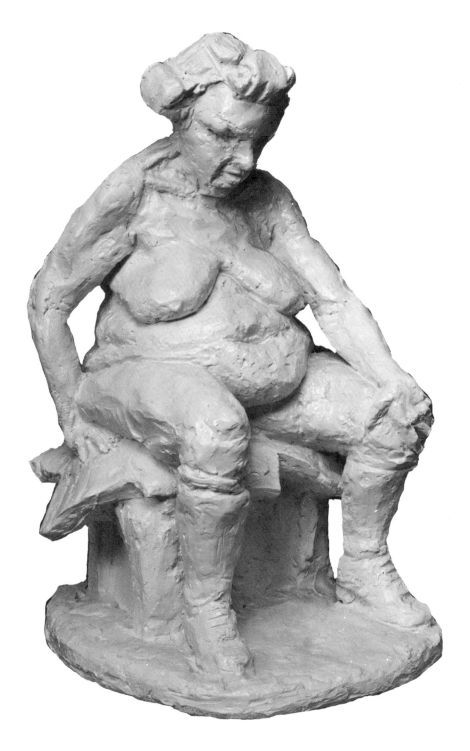

A head modeled in wax.

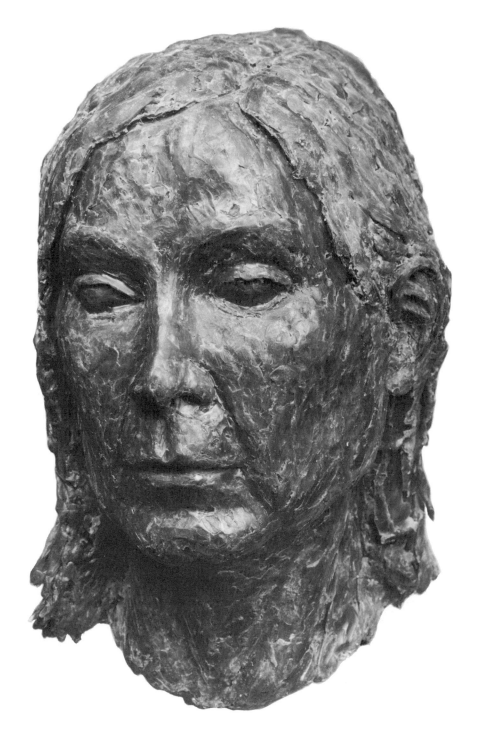

Modeling in self-setting clay, which does not necessarily require casting.

Advanced stage in the permanent clay figure.

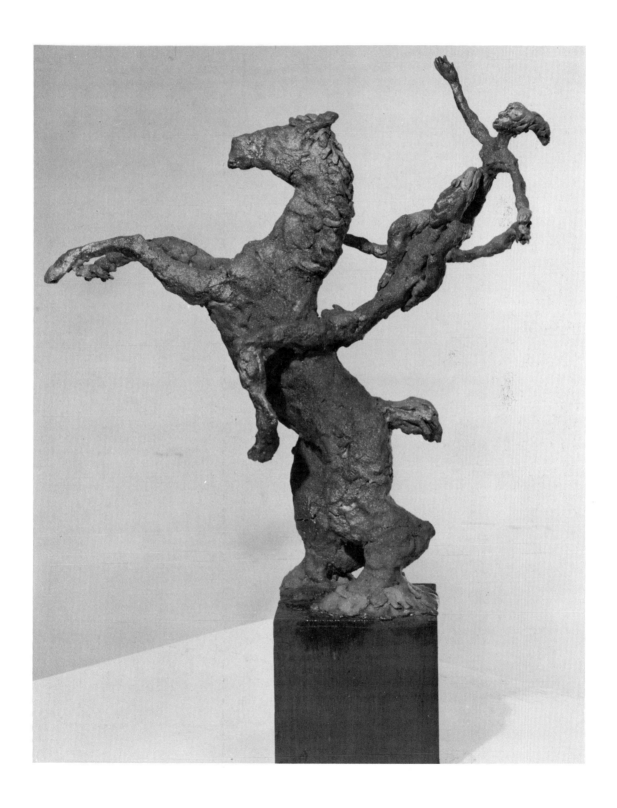

Modeling a low relief

A rough-surfaced modeling board made of planks should be used as a base for modeling a low-relief piece.

The clay to be used for modeling may be of any of the many varieties, because the final piece will be cast from the clay model.

Casting

Waste-mold casting

The process of casting in plaster is almost as old as sculpture itself.

The primitive sculptor soon noticed that the pressure of a foot in wet sand produced a negative facsimile of that foot. What could be more obvious than to fill that mold in the sand with wet clay? When the clay hardened, a positive reproduction was taken from the negative impression in the sand.

Plaster of Paris is procurable almost everywhere. Its uses are innumerable. Its quick-setting character makes it indispensable as a cast for broken bones. It is used in vast quantities by wall-plasterers. It is by far the most common material used in making cheap reproductions of works of sculpture.

It is also the most practical material to use for molds, which act as the negative form from which the reproduction is obtained.

It can be bought in powder form in any paint supply store. The sack of plaster may have lumps and chunks of congealed powder that should be carefully broken up into smooth powder form before using. Sift the powder, either with your fingers or with a sieve, until its consistency is soft and the lumps are gone.

Here is a list of the objects you will need in making a plastic mold:

1. Basin for mixing the plaster.
2. Brush for smearing plaster on the original piece.
3. Brass "shims." These are used to form the thin wall that separates the two halves of the plaster cast.
4. Bluing tint. This dye is added to the first plaster cast nearest to the clay model so that the sculptor can readily distinguish this inner layer of the mold both from the subsequent outer layers and from the original model and the final cast within.
5. Burlap strips. These may be put into the plaster periodically as the coats are added. They help strengthen the mold.
6. Lead tubing. This is also used to strengthen the walls of the mold.

Before beginning to apply the plaster to your clay figure you must

decide which are the best points for the separation of the two parts of the cast. Most often the line of demarcation should be along the sides of your piece, separating the front from the back.

You should then insert a line of brass shims in the clay figure. If it is still wet, they may be attached with ease. If not, a freshly diluted solution of clay may be used to fix the light brass shims. The shims should extend beyond the thickness of the mold walls, which should be at least one inch in thickness. Of course the thickness and the strength of the mold will depend on the size of the piece to be cast.

Mix more than the estimated amount of plaster for your mold. It is inexpensive, and a mold with walls that are too thin can be a disaster.

The consistency of the plaster when diluted should be that of a flowing paste, thick and creamy. Add the bluing to it to give it a tint different from the subsequent positive plaster of Paris cast. If the walls of the mold are to be thick, use bluing only for the first, inner layer.

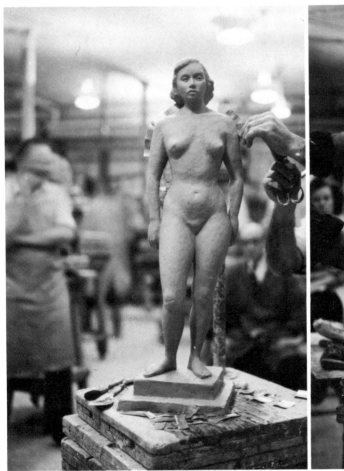
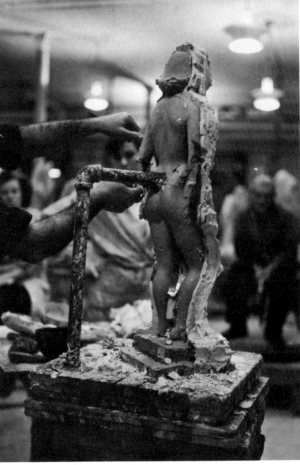

Using your fingers scoop-fashion, begin to slap layers of creamy plaster on to your original. Be careful that every crevice is filled and every undercut thoroughly covered.

Build up your mold to a good thickness (about an inch for small molds, heavier for larger ones).

Add burlap strengtheners and metal strips if you want greater strength.

Try to leave the ring of brass shim separators exposed. If they are covered in a few places, the set plaster may be scraped off.

Now allow the mold to set thoroughly.

The time required for setting depends on room temperature and the liquid character of your plaster. However, plaster hardens very quickly.

When you feel that the mold is fully dried and sturdy, you may begin to pry apart the two halves of your mold at the shim dividers. Do this with care, because your work will be wasted if you do a ragged separation job.

You now have the two parts of your mold ready for reassembly. Clean

Opposite left: Applying the shims.

Opposite right: Shims applied, rear view.

Right: Mixing plaster for the mold.

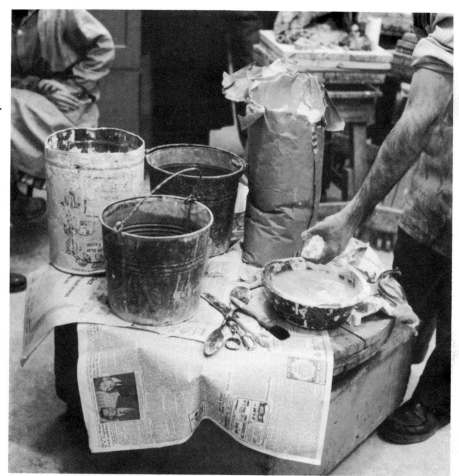

the interior of each, removing bits of clay or other material that may have stuck to the plaster walls. These, of course, will not be tinted blue and therefore will be easily recognizable.

Now paint the interior parts of your mold sections with a few coats of green soap, diluted in water, to give it a thin film covering. This will act as a separator between the poured plaster and the mold. Now you are ready to join the parts.

Casting in plaster of Paris

As we have pointed out, plaster of Paris, in addition to being the material most frequently used for the negative mold — the transition stage from the fragile, temporary clay model — is often also used for the relatively hard, permanent final cast.

It is inexpensive and may be bought from any paint supply shop.

When properly prepared by being mixed with water and stirred to the correct flowing consistency, it dries quickly in the mold, expanding sufficiently

Left: Applying creamy plaster to the clay figure original.

Right: Build coats of plaster to a good, strong thickness.

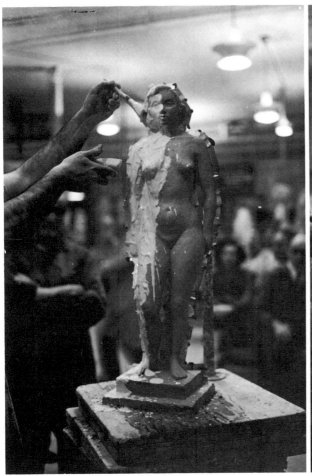
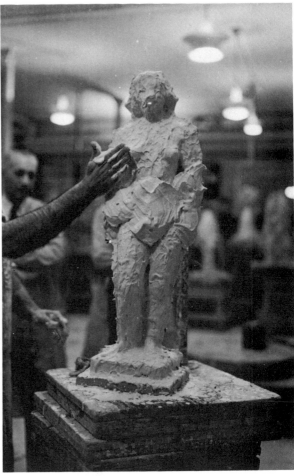

to fill every subtle crevice in the mold's interior, thus reproducing every facet of the clay original.

The plaster, in powder form, is spread in sifted doses upon the water in a tub. It must never be added in heavy lumps, which will merely congeal.

Stir constantly with a stick while slowly adding plaster until the proper mixture is achieved. It should be of a consistency thick enough to dry to a firm, strong state, but liquid enough to pour freely into the mold and to spread within to fill every contour thoroughly. A thick, creamy quality is desirable.

The first application of the mixture to the hollow mold should be aimed at the sides of the mold, blown in under pressure. A pastry cook's whipped-cream syringe may be used effectively for the purpose.

Blowing in this first covering layer under pressure will help prevent air bubbles from forming between the mold walls and the fresh plaster of Paris.

The drying period varies with the size of the figure to be cast. Twenty-four hours usually is sufficient.

The mold is then gently chipped away from the figure within.

Left: Try to leave the tops of the brass shims exposed.

Right: The back half of the figure now must be similarly covered with plaster.

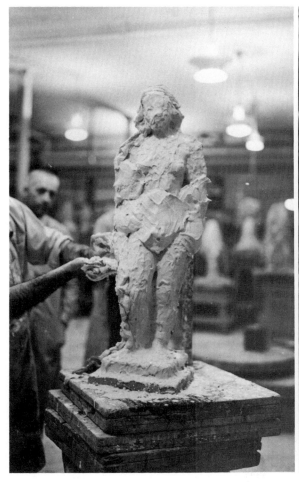

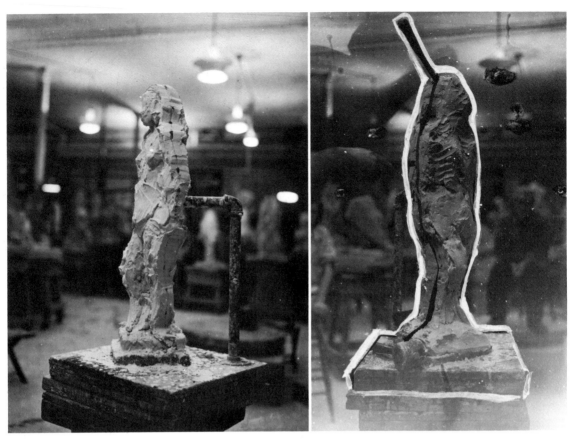

Allow the mold to set and dry thoroughly. When the mold has set and hardened, begin to remove sections at shim division points. When the interior walls of the mold are cleaned, apply coats of green soap diluted in water to aid in separating the mold from the cast figure.

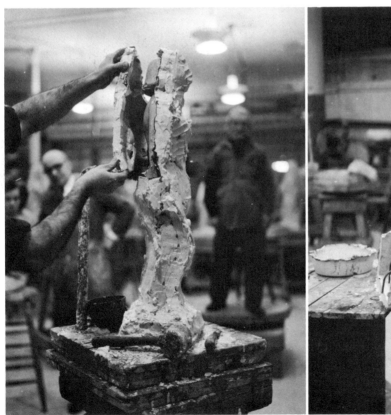

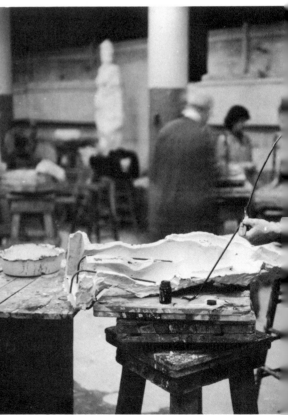

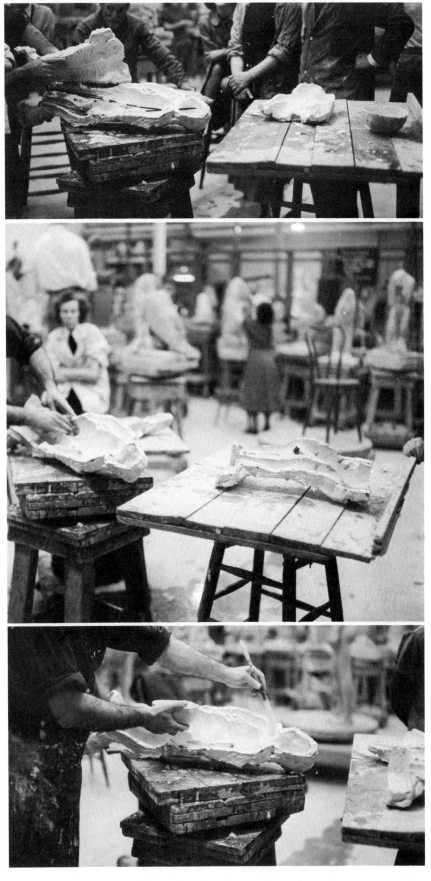

Clean the interior of the mold of bits of clay that may have adhered to the walls. Painting with green soap. Ready for joining.

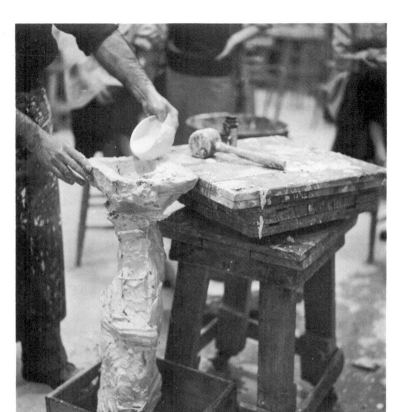

Pouring the plaster.

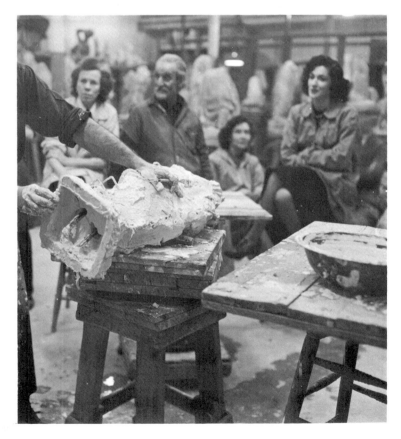

Assembling the mold.

Removing the mold.

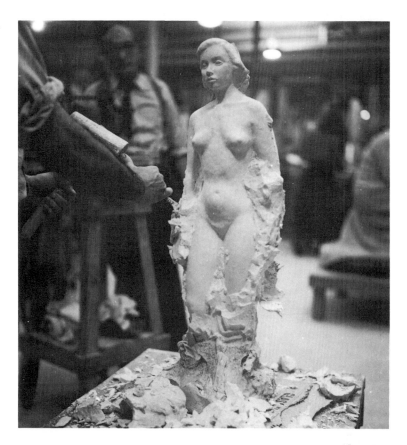

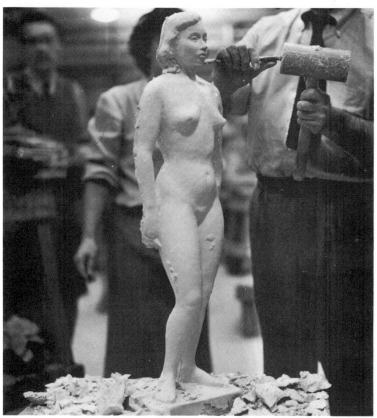

The lost-wax cast

Ancient peoples discovered the lost-wax method of casting in bronze. The Greeks cast most of their splendid bronze sculpture using this simple procedure for transferring a piece of sculpture from one material to another.

The figure to be cast in metal is first modeled in wax. It is then coated with a thick layer of pottery clay.

The next step is the firing of the clay-covered figure in a kiln.

The wax figure under the clay melts away under the heat and the pottery covering is hardened, its now hollow interior walls bearing a perfect imprint of the "lost" wax figure.

Molten bronze is poured into the clay mold using the same aperture through which the melted wax was poured away.

When the bronze has cooled and hardened, the clay outer coat is removed and the bronze replica is revealed.

Casting stone

"Stone" for casting is available in powder form. When water is added, a pourable mixture results, from which casts may be made that resemble the texture and have the hardness of natural stone.

Casting stone is available in various colors: white, gray, black, brown, and green.

Masks

Life masks and death masks are produced by making a mold directly on the face of a person.

Oil or grease is first applied to the face to prevent the plaster of Paris or wax mold from adhering to the skin.

Roman death masks were made of wax. Ancient Egyptian masks were often made of thin gold plate.

When plaster of Paris or wax is used, the coating is removed from the features when dry and acts as a mold for casting a perfect likeness.

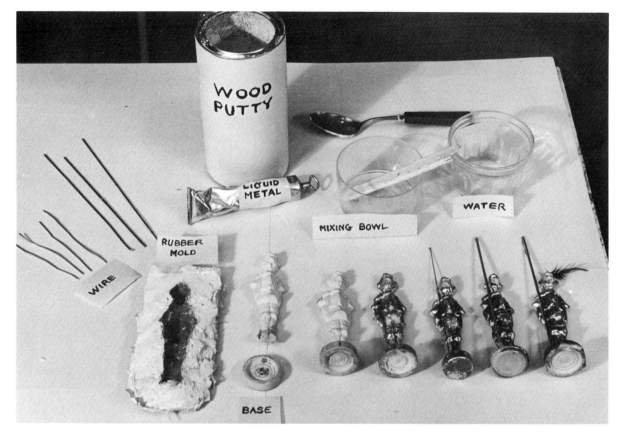

A rubber mold made from wood-putty carving and cast in liquid metal.

The rubber mold

A more modern method of casting is the rubber mold. This method, however, is better suited to reproducing small figures than large.

The procedure is extremely simple because of both the pliant nature of liquefied rubber, which makes it easy to apply, and the sturdy properties of solidified rubber, which permit removal of the cast from the figure and reassembling with little trouble. The rubber mold may be reused without damage to its walls.

Liquefied rubber, which may be bought in cans, is poured over the original figure. Coat after coat is applied. When the series of coats reaches a thickness that will not expand too much under the weight of the plaster to be poured in later, the rubber is permitted to dry.

A careful slit is then cut around the rubber mold from top to bottom. The two parts of the mold are gently peeled off.

When the parts have been joined and a pouring hole has been cut in the top, the casting plaster is poured in and the impression obtained.

Modeling for firing

Kilns for firing are manufactured in various sizes and shapes. There are relatively inexpensive small electric kilns that are quite adequate for baking small pieces. For elaborate ceramic sculpture to be baked under carefully controlled temperatures and timing, sculptors often resort to kilns in commercial ceramics factories. There, experienced men perform functions that would be tedious and time consuming for the artist. The actual modeling of the figure for firing and the preparation of glazes (if desired) are the sculptor's functions.

Clays of various qualities are combined for best drying and firing purposes. These are calculated on the basis of their resistance to shrinkage and warping as their liquid content evaporates before and during the baking process. "Grog" added to the modeling mixture acts to minimize shrinkage. Another additive, called flint, has similar qualities. The catalogues of sculptors' supply houses list such ceramic mixtures.

Except in the case of very small, compact pieces that are solidly and densely packed, figures planned for firing should have a hollow interior. The surrounding walls should be of fairly even thickness and carefully freed of air pockets.

The usual method of hollowing out the interior of a figure to be baked in the kiln is to model it solidly first. Then a half section is cut away with a wire. The core is then dug out of each section, leaving strong, fairly thick outer walls. The two parts are carefully rejoined and will adhere if sufficiently damp. The interior and exterior joints are then firmly smoothed over with fresh clay.

All this, of course, must be accomplished before the clay figure has dried.

During the working procedure, water should be sprayed on the clay surface twice a day in order to keep it from drying too quickly. Be careful not to soak the clay. A fine spray from an atomizer is sufficient.

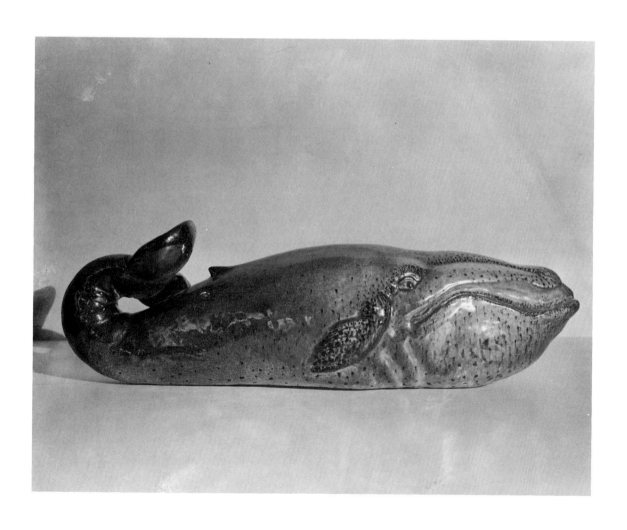

Glazed pottery. "Whale," 1936, by Carl Walters.

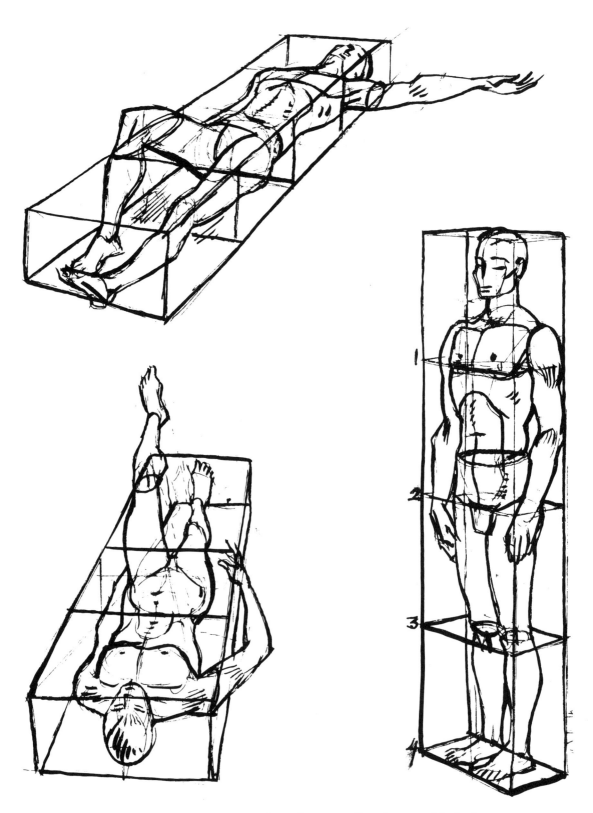

*Working plans for the figure that is "contained" within your block of stone.
Obviously, protruding forms beyond the block of stone are only made possible by
bolting stone to stone, not an advisable procedure.*

Carving

The most difficult and at the same time the most creative part of the process of carving in stone or wood is that of "seeing" the prospective figure within the block of material.

The concept must be, in part, dictated by the outer boundaries of the block. The sculptor must visualize the possibilities that lie within those limits. He cannot project forms by merely adding a wire armature and covering it, as he could with clay. Arms or legs extending beyond the block would have to be "pinned" on, an unsculptural procedure.

As a potential carver, you must plan the ultimate piece in advance with far more precision than if you were working in the modeling medium of clay. You cannot change your mind to any drastic extent during the carving procedure once you have begun to reach within the solid form to find the shapes you originally planned.

Your chosen subject should be one that "lives" comfortably within the block until you release it, using all your taste and creative imagination, subject always to the block's own potentials.

After you have chosen your theme and made your working drawings (much the same in their purpose as a dressmaker's pattern or the plans from which a carpenter works), you must begin to cut away the shell that imprisons your figure.

Obviously, the stone or woodblock chosen for carving should not be enormously larger than the piece planned. The waste of energy and good material would be unfortunate, but the danger of boredom is the most serious effect if long, arduous chopping is required before the piece is roughed-out and ready for the pleasures of creation.

When the outer boundaries of the figure have been reached, a pause is suggested. The purpose is to readjust the hand and eye to a new tempo of cutting. At this point no ill-considered incision, no imbalance in removal of masses due to over-muscular chopping is permissible. You are now faced with decisions that will take you to the point of no return.

Choice of carving media

Each medium imposes its own disciplines on the sculptor by its nature. When the sculptor fights the essential character of that medium, he inevitably sacrifices some quality and much energy.

To give an extreme example of such violation of the natural properties of material, for a sculptor to carve rugged figures in ivory and delicate, intricate ones in granite would be a waste of the potentials of both materials.

But the daring and technical virtuosity of an artist should not be restrained by restrictions. One cannot arbitrarily say you may or may not carve a butterfly in a particular stone or a charging lion in another.

The fact is that the sculptor of most periods in art was restricted, for the most part, to the materials naturally available where he lived, and he usually overcame the restrictions imposed upon him, if he so desired, by working the stone he had in such ways as he pleased.

Only in one or two hills near Peking, China, is a magnesium silicate stone called steatite to be found. It is black and takes a beautiful polish. The Chinese of that area have sculpted delightful figures and animals in it, seeking out its special traits but inventively adding their own modifications.

More restrictive to the artist than the material available has usually been the style imposed upon him by his masters, by his customers, and by religious ritual.

The weird giant monuments on Easter Island, almost identical in design, were obviously created by many workers in stone, serving some compelling force that severely dictated the character of their works.

The theatrical techniques that worried and fretted reluctant stone in the baroque and rococo periods were often not freely decided upon by the artist nor influenced by the material to any great extent.

Present-day transportation facilities and widespread travel have taught the sculptor that there are innumerable varieties of carving material at his command — possibly too many — making choice difficult for the novice.

Try a few different carving media but do not use so much time and energy choosing one that you neglect creation in favor of research.

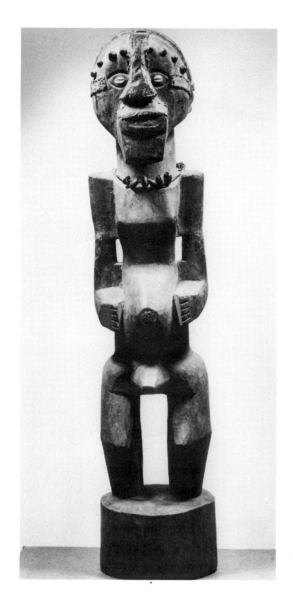

Wood sculpture by Africans.

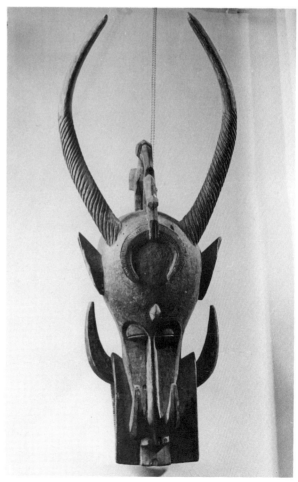

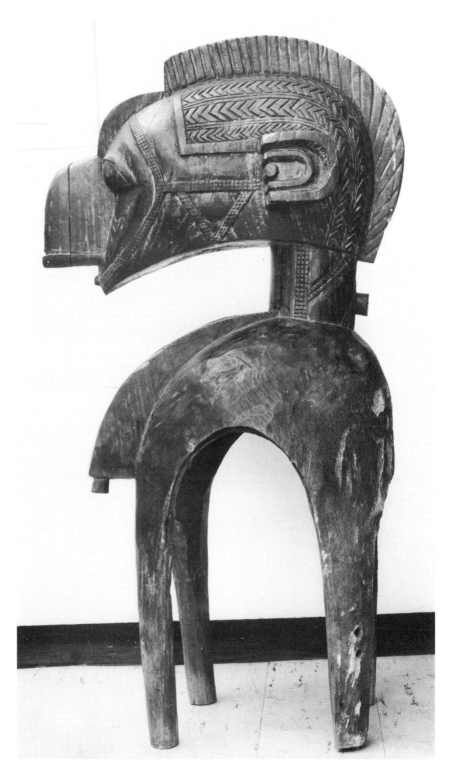

*Another imaginative wood carving
by an African.*

Wood

Whittling has apparently long been an activity of man and boy.

The first possession of a knife led inevitably to the search for a suitable substance on which to try its keen edge.

Wood of a thousand varieties lay all about. From knife-testing there followed naturally the fashioning of figures from this tractable material, wood.

But all woods are not sufficiently soft to whittle, and the hammer and chisel were brought into play.

Thousands of delightful and witty pieces, reverent and humorous, profound and playful, have been made by primitive peoples in all parts of the world.

People in places remote from each other learned to carve their local woods and produced their own styles.

In Bali, where wood carving is still considered a normal activity of every man, fine sculpture of wood was and is an almost universal accomplishment.

Natives of the Congo have produced figures and masks of great artistic quality; the Indians of Alaska and the Pacific Northwest made giant totem poles, using whole trees on which they carved their tribal history in vertical patterns.

The special qualities of each kind of wood — its grain and natural color, its hardness or softness — call for a choice of the proper tools for the particular wood and contribute to the wood's suitability for certain subjects more than others.

Begin your wood-carving career with the relatively soft woods, which will not "fight" you to the point of discouragement.

Well-dried wood for carving is available through sculptors' supply houses. Balsa, bass, birch, ash, pine, cedar, ebony, cherry, lignum vitae, mahogany, rosewood, teak, and walnut are a few of the many woods suitable for carving.

Casting of a section of carved wooden door, 1810, Yoruba tribe.

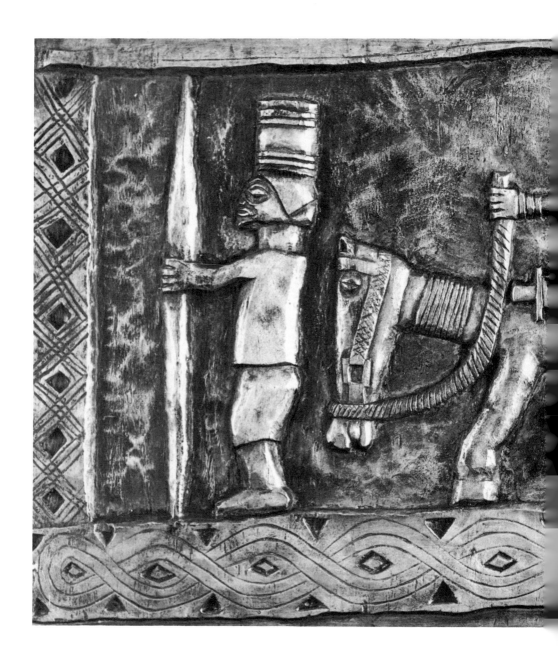

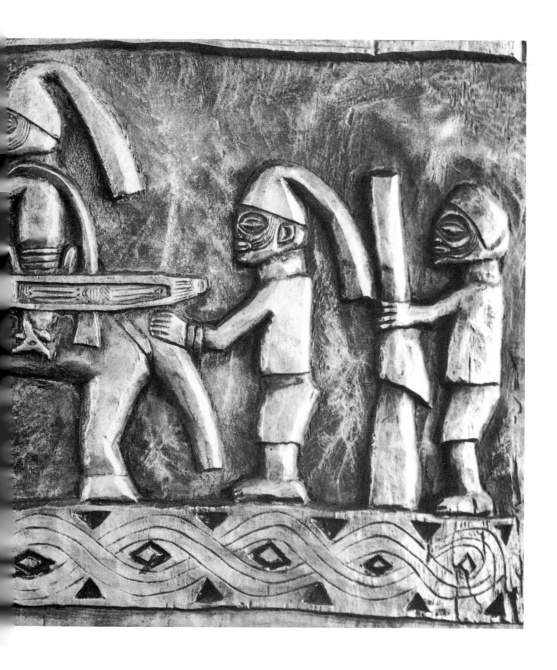

The basic tools for wood carving are flat chisels and gouges. Flat chisels, beveled to a very sharp edge, are made with handles suitable for striking with a mallet or with palm-fitting handles suitable for use without a mallet. Flat chisels cut a flat sliver of wood at every stroke of the hammer or push of the hand. Gouges have curved, hollowed, or V-shaped blades. These cut a furrow like that of a plow in the earth.

The mallet for wood carving is made of hardwood.

Hand sanders or power sanders may be used to smooth and polish finished wood sculpture pieces.

Kits of tools for wood carving are available in art supply shops at quite reasonable prices. They are adequate for most wood carving except when working with especially hard wood or carvings of monumental proportions. For such ambitious undertakings tools must be obtained from a company that specializes in sculptors' supplies. (See page 173.)

A hardwood mallet and several chisels and small gouges.

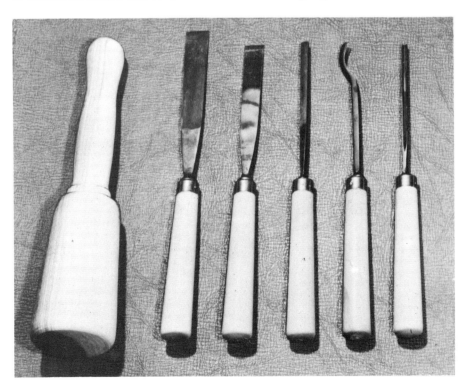

Small tools used for bas relief carving.

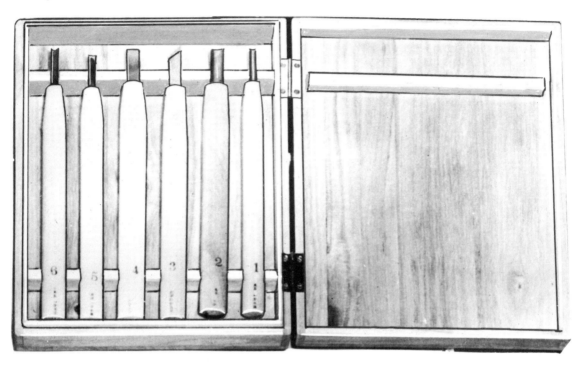

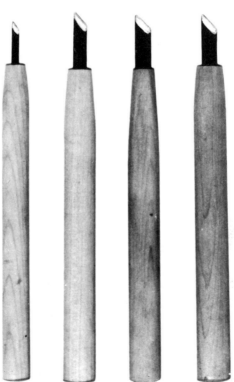

*Wood-carving kits are available with a selection to cover
most wood-carving needs.*

Palm-fitting handles on small chisels and gouges to be used without a mallet for detail work.

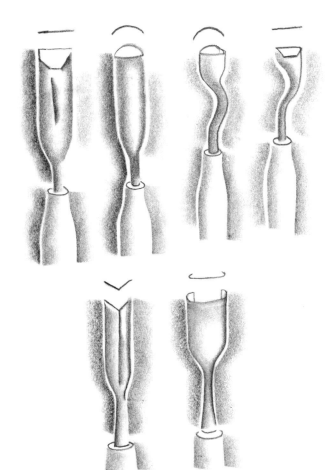

A set of gouges demonstrating the various cutting edges. These are used mostly on relatively soft wood carvings.

Mallet and chisel carving.

Preliminary step in finding the figure within.

A wooden figure in various stages of completion.
(1) Cutting with chisel and metal hammer.

(2) Smoothing with a rasp.

(3) Continuing the polishing process with a rasp.

Boxwood. "Domestic Scene: High Relief," Flemish School, seventeenth century.

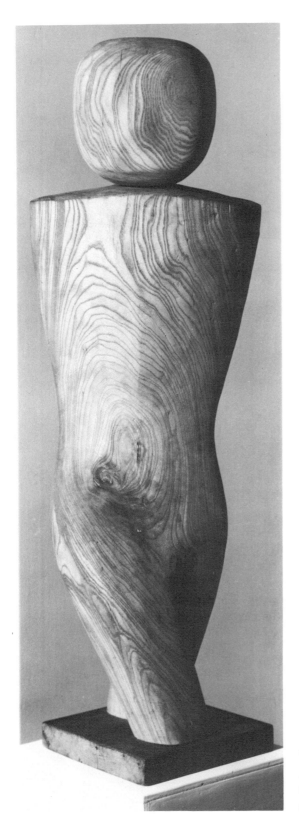

"Figure in Elm," 1948, *by Raoul Hague. Notice beautiful use of grain in this strong, simple figure.*

Stone

Stone has been used as the natural material of the sculptor since pre-historic days. It has remained a popular medium, although the more restless moderns are somewhat impatient with its resistant surface and its restrictive boundaries.

The ancients found it readily available in large quantities all about them, and it was inevitable that this ubiquity and its durability would attract them for the depiction of their gods and heroes.

The Egyptians found granite most suitable. They thought in terms of eternity, and the hard compactness of granite promised great endurance against erosion by sand and water, wind and sun. That promise has been fulfilled for four thousand years. Their great monoliths have been preserved in a far better state than the sculpture of other ancient peoples.

Marble was the favorite of the Greeks. Its serene beauty lent itself exquisitely to the expression of their pleasure in carving smooth images of their gods and goddesses, of their athletes and dancers.

India, a country of amazing fecundity in art, abounds in magnificent sandstone sculpture, although Indian artists used marble in great quantities as well.

The Indian sculptors — and there must have been countless thousands, considering the quantity of figure and animal carvings to be seen everywhere in that huge country — managed to impart a fleshy, lifelike quality to their sandstone. Their figures writhe in love or religious passion or they perform the commonplace tasks of daily life with a warm realism rarely imparted in stone.

The great Mayan civilization in the Americas worked in all the stones at hand. Obsidian was used both for cutting instruments and as a sculpture material. Its smooth hardness and durability plus its presence in large

quantities in what is now Mexico influenced the choice of this beautiful natural glassy stone.

The Chinese worked wonders in jade, ivory, lapis lazuli, and amethyst.

The Japanese used these stones as well, in addition to creating many fine carvings in rock crystal.

A rich period of stone carving was that of the Khmer kingdoms during the Middle Ages in what is now northern Thailand, Vietnam, and Cambodia. Artists of this period sculpted powerful figures and heads, using a variety of stones, but mostly sandstone and limestone.

However, all the great art-producing countries had artists who departed from the conventional materials of their era and experimented with the wide range of stones and gems available. In the present period, in the United States and Europe, marble is the most popular stone for sculptors. Because marble is available in such a wide range of color and grain design and because of its relatively easy-cutting character, its beauty, and its durability, it has replaced most other stones for use in sculpture.

An Assyrian bas relief sculpture.

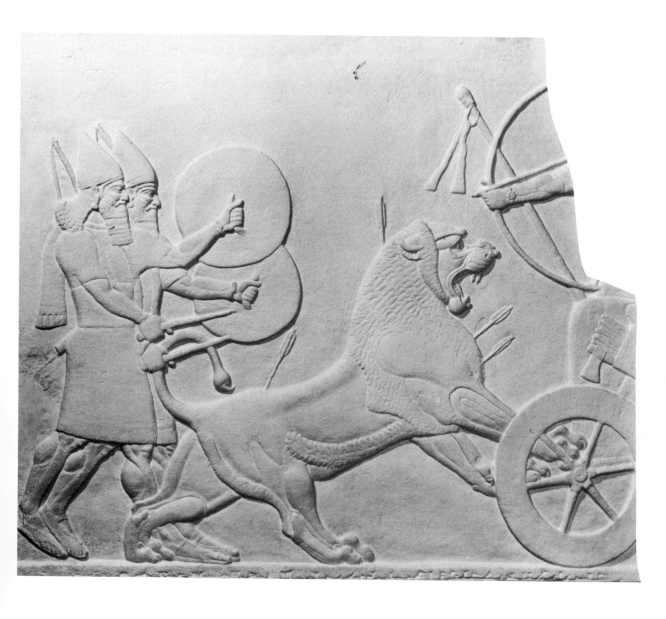

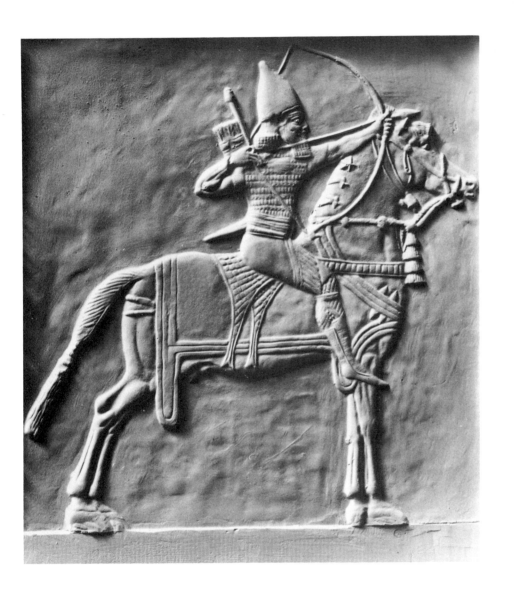

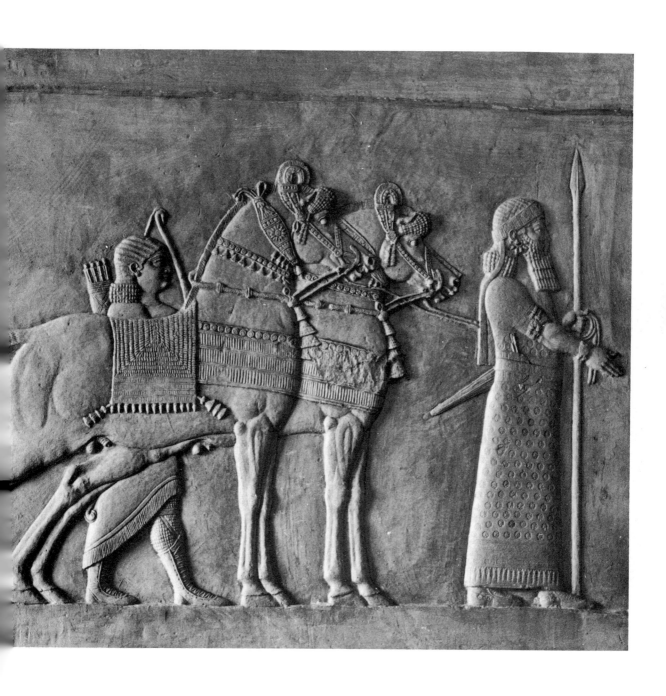

Assyrian bas relief sculptures.

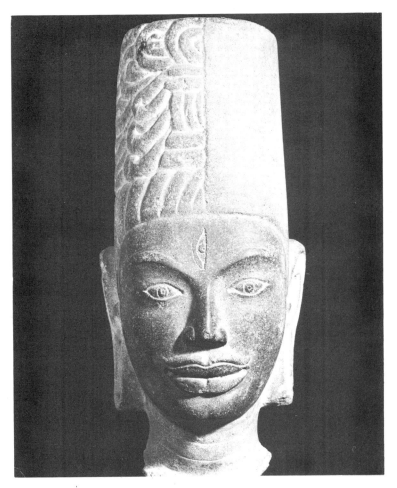

Ancient stone head from Vietnam.

Stone treated with wit and playfulness. High-relief sculpture from Cambodia.

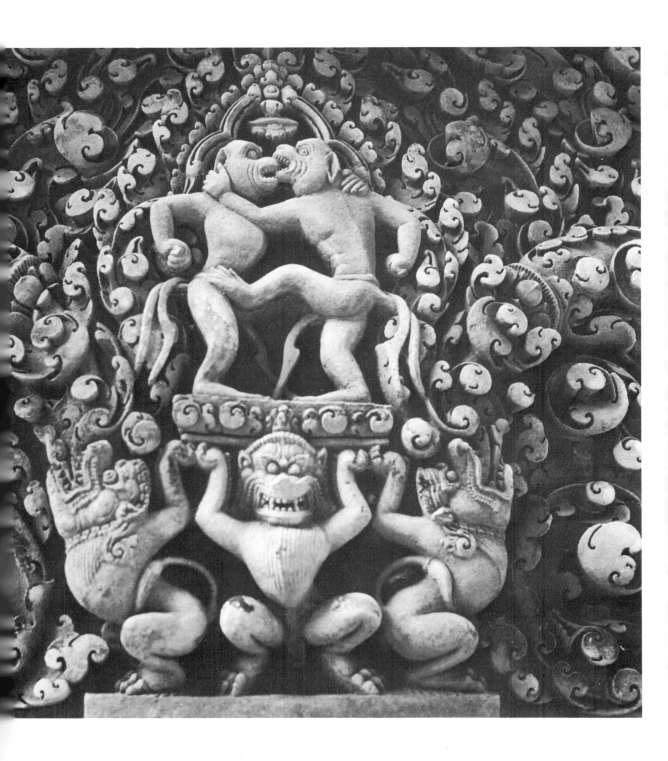

Opposite: Amusing stone bas relief from Vietnam area.

"Nandy," a stone sacred bull from Cambodia.

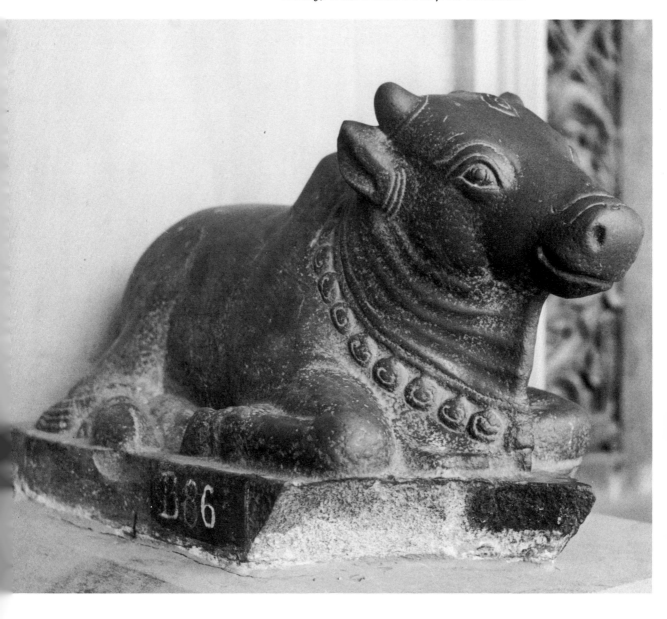

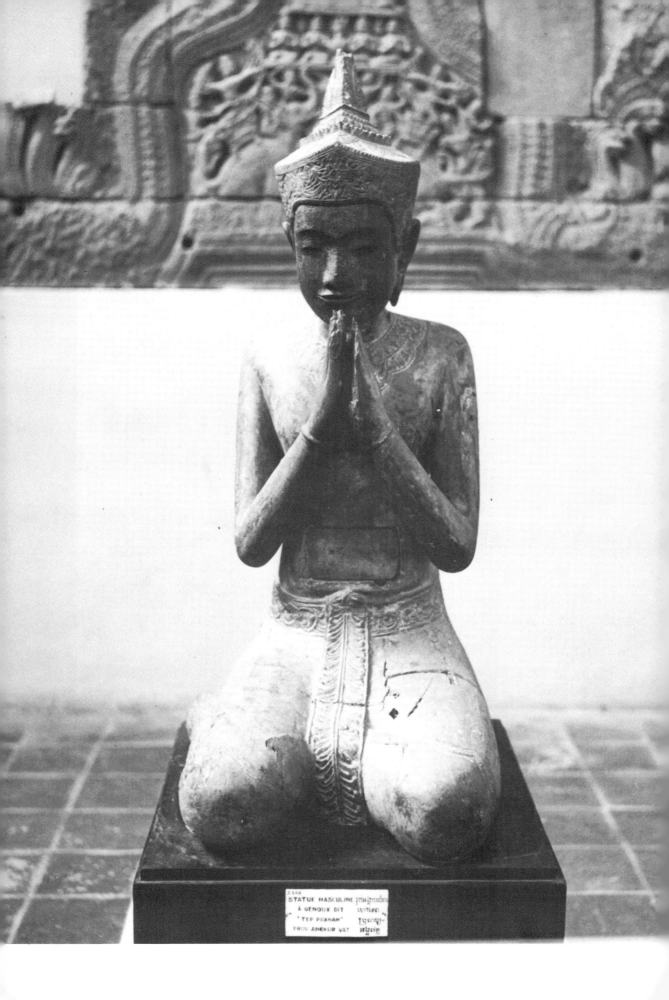

STATUE MASCULINE រូបសត្វ្រ្ថុ្កព្វៗ
À GENOUX DIT ដោងគង់
'TEP PRANAM' ថេបប្រណម្យ
PROV. ANGKOR VAT អង្គរវត្ត

Opposite: Figure of a man praying, Cambodia.

Religious sculpture, Cambodia.

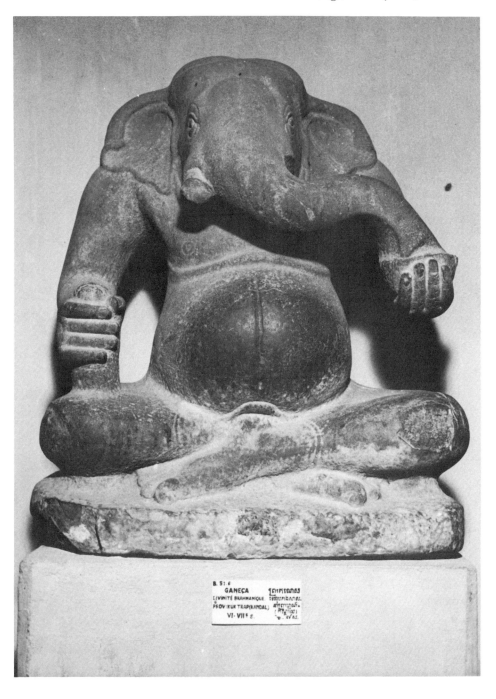

"Sacred Garuda and Five-headed Naga," Cham art, Vietnam.

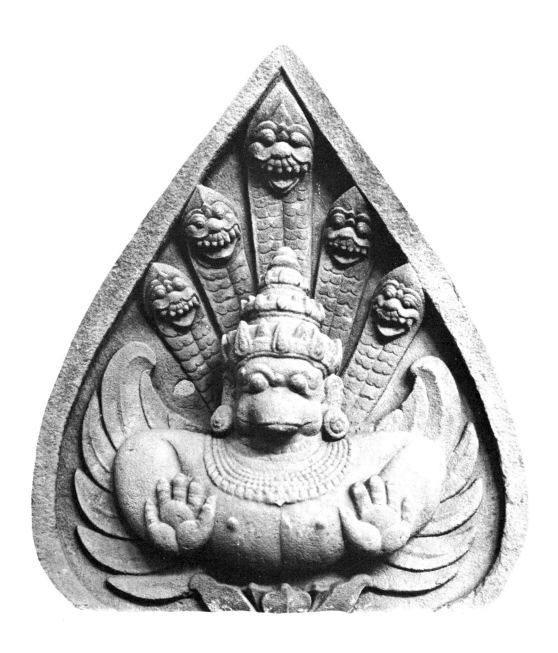

Female torso, Cambodia.

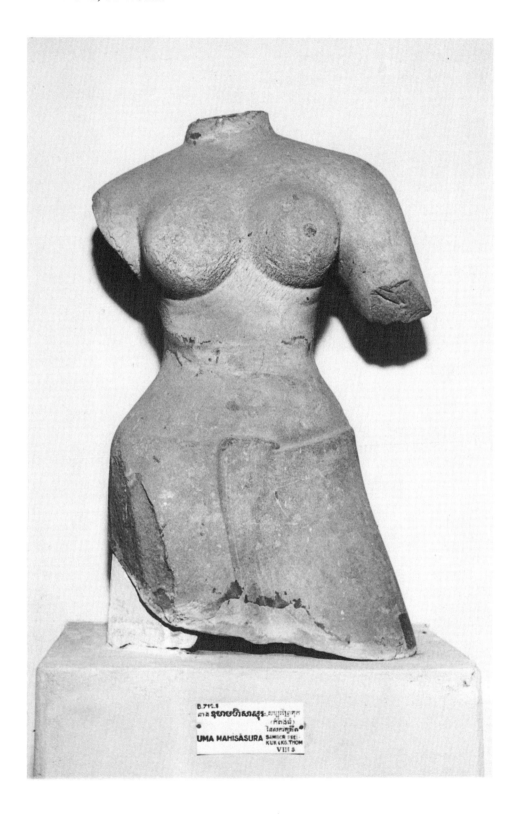

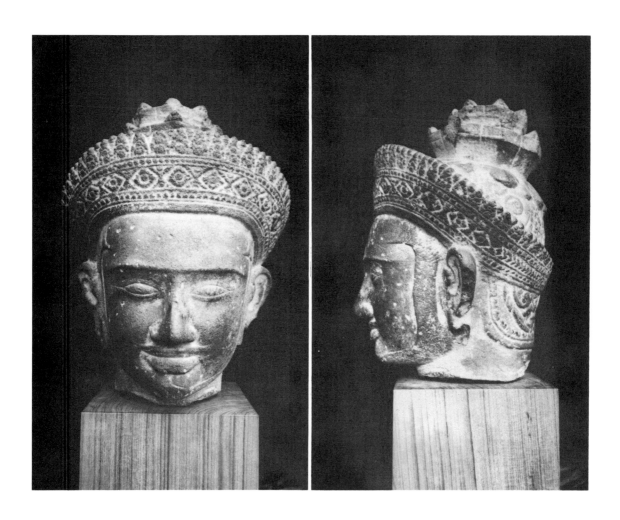

Kmer sculpture.

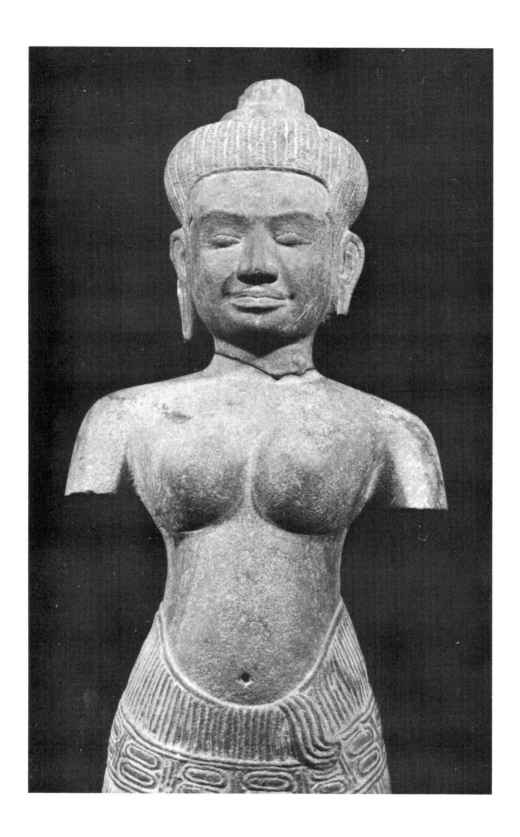

"The Wrestlers," attributed to Cephissodotus. From a cast in the Corcoran Gallery of Art.

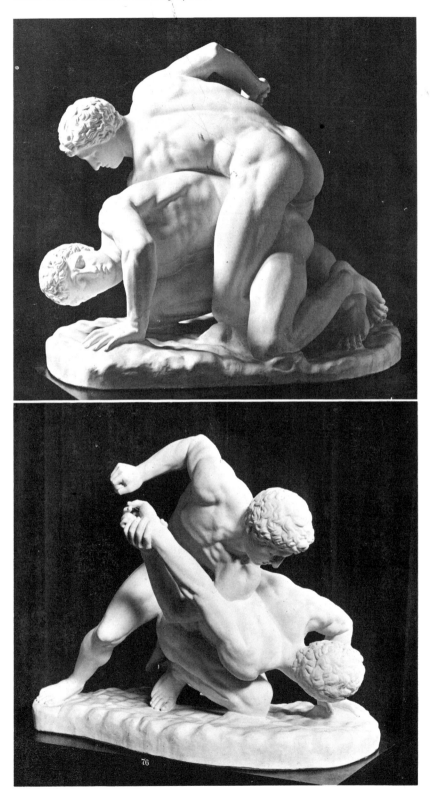

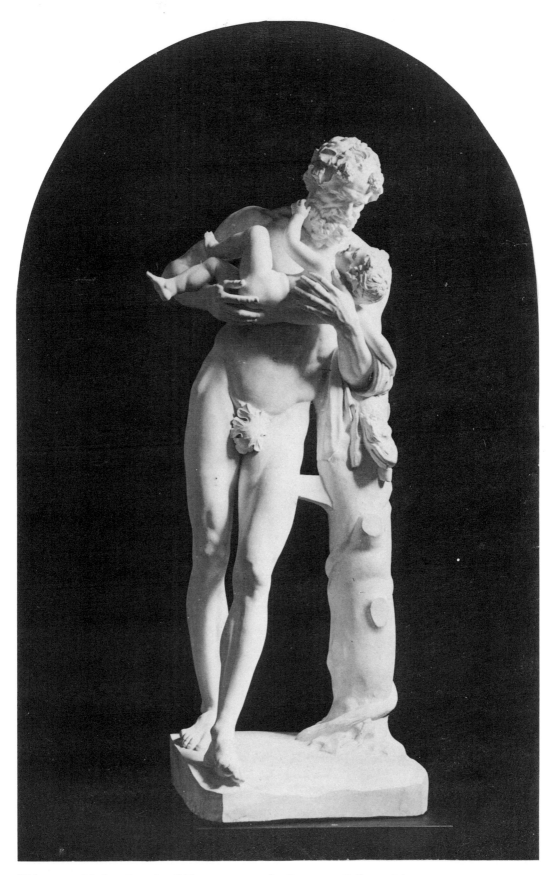

"Silenus and Infant Bacchus." From a cast in the Corcoran Gallery of Art.

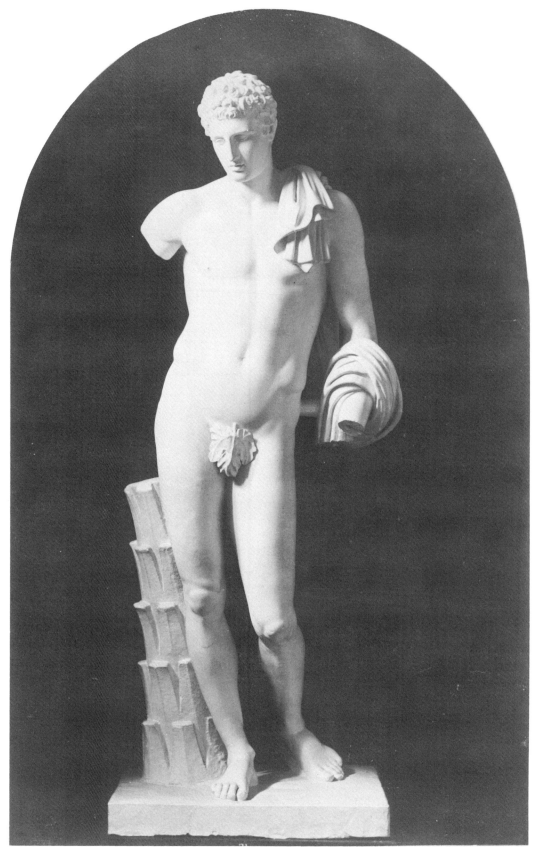

"Mercury." From a cast in the Corcoran Gallery of Art, taken from the original marble in the Vatican.

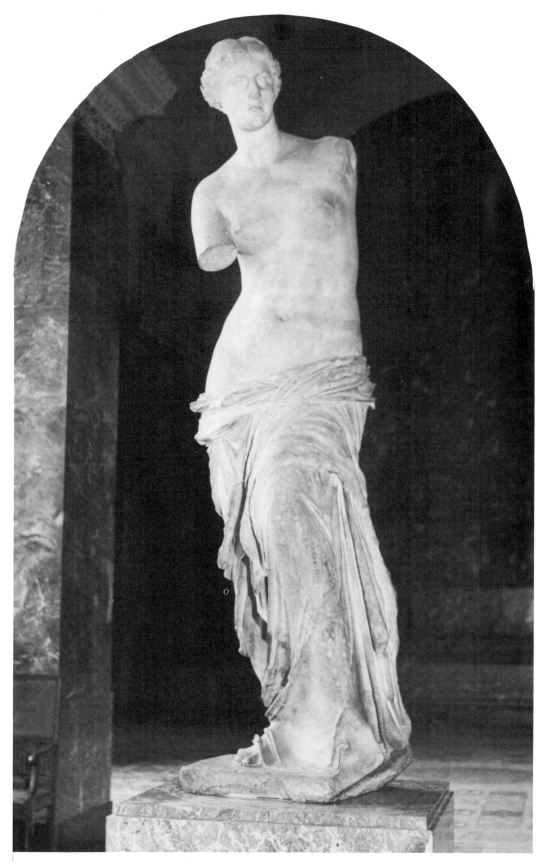

"Venus of Milo."

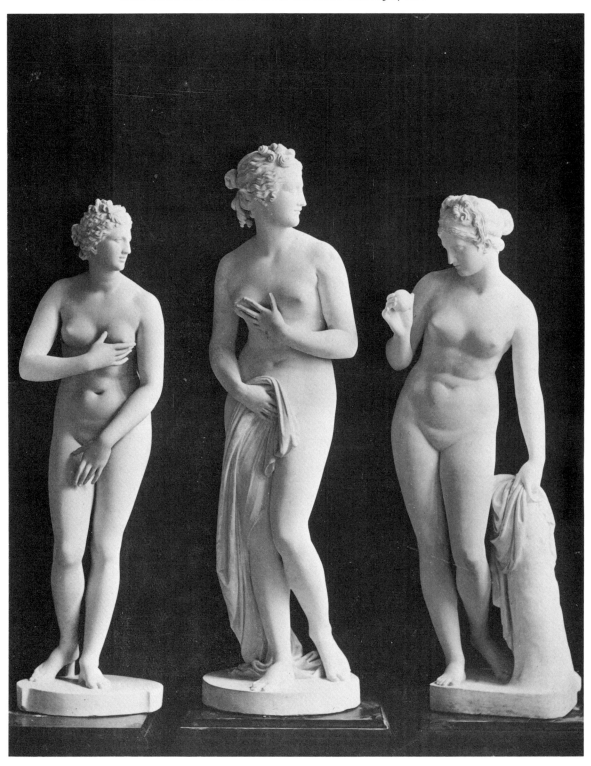

"Venus de Medici." "Venus" by Antonio Canova. "Venus" by Bertel Thorvaldsen. From casts in the Corcoran Gallery of Art.

"The Prisoners" or "The Slaves," by Michelangelo. From a cast in the Corcoran Gallery of Art.

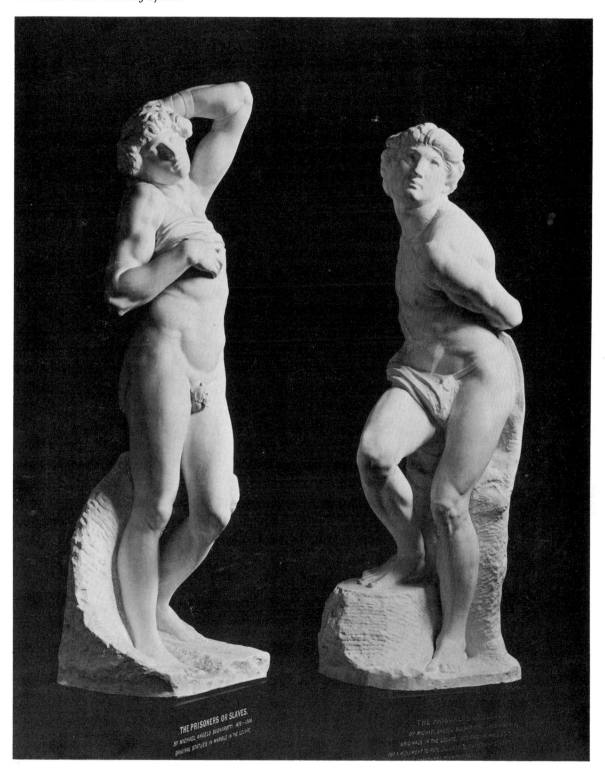

THE PRISONERS OR SLAVES.
BY MICHAEL ANGELO BUONAROTTI, 1475—1564.
ORIGINAL STATUES IN MARBLE IN THE LOUVRE

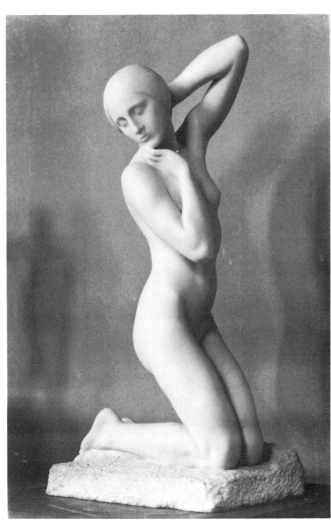

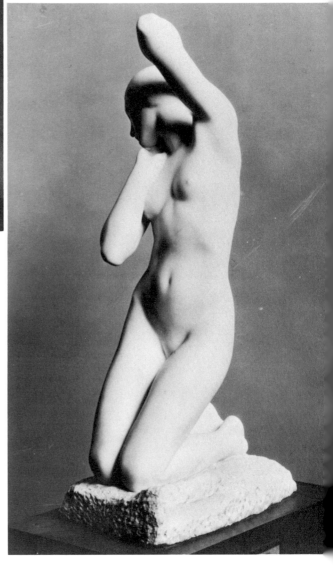

Marble. "Fragelina," by Attilio Piccirilli.

Marble. "Mother and Child," by William Zorach.

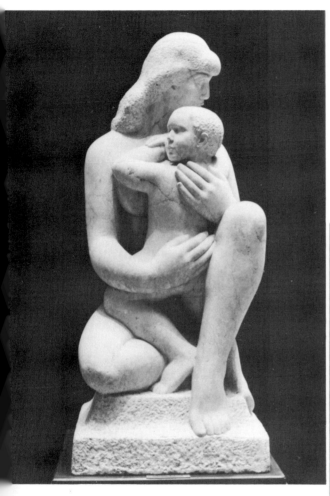

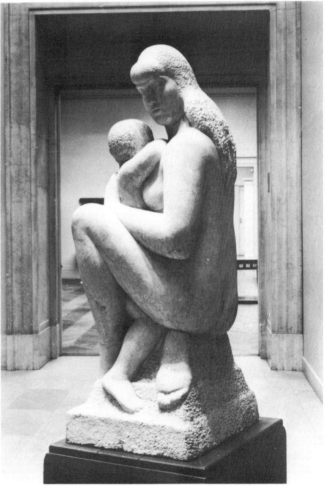

Tooth chisels are used in various stages of the shaping process. They have from four to eight sharp teeth ranged in a straight line.

Point chisels are used in the early stage of shaping from the block in the process of "reaching" the outer shapes of the figure-to-be. The size and weight of the chisel is dependent on the size of the block to be trimmed.

Flat-edged chisels are used for chipping close to the outer limits of the figure being carved.

Bushing chisels are used to pulverize the stone on the surface of the figure and to "dress" it, ready for the final smooth polish. On the face, which may be either square or round, is a set of projecting points.

Rasps and files, ranging from fine to coarse-toothed, are used for rounding and smoothing surfaces of the carved figure.

Rock hammers are made of forged steel and are used directly on the stone in the roughing-out stage or for cracking off large chips.

The Roto hammer is an electric tool used for roughing-out and carving. It can save many hours of hard hand chiseling.

Bushing hammers, like bushing chisels, are designed to be used directly on the stone to cut away areas close to the figure. They are made of hard steel with toothed edges for pulverizing the stone with short blows.

Hardwood mallets are used to strike the chisels. Sculptors use wood in preference to metal hammers to ease the shock on themselves, the tools, and the stone.

Metal-head mallets are used for large, rough stone shaping where rugged blows are needed.

Sharpening stones are abrasive whetstones for sharpening edged tools. Use water on the stone while sharpening.

Carborundum is an abrasive for polishing. Coarse-grained carborundum is used first, and then progressively finer grains as the polish becomes smoother.

Bases and pedestals for sculpture pieces are part of the design of the whole concept. The proper base can enhance your piece enormously. It may be made of wood or stone. Some sculptors now use Formica bases.

Eyeshields or plastic eyeglasses should be worn when doing violent chipping in stone. Flying fragments and stone dust can be dangerous.

Metal hammer, plane, and tooth chisels for stone carving.

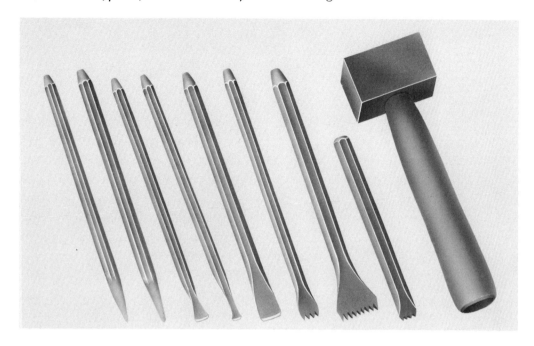

Rasps for smoothing and finishing.

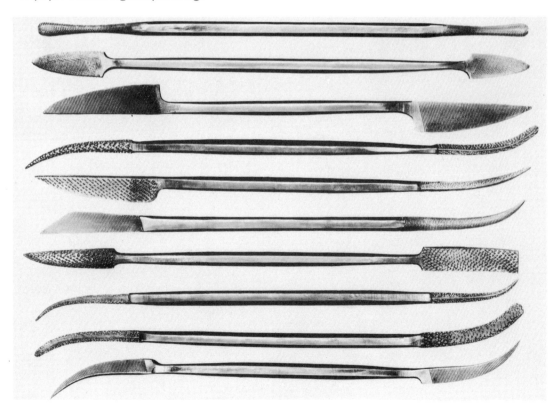

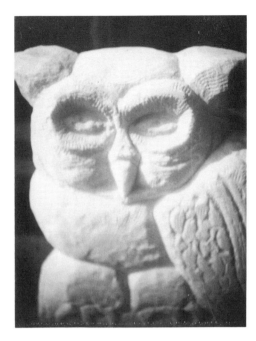

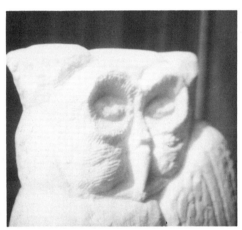

"Owl," by Arthur Zaidenberg. Compact, high-relief, marble piece mounted on a block of rough fir. It is unpolished; the tool marks are used to suggest the texture of feathers.

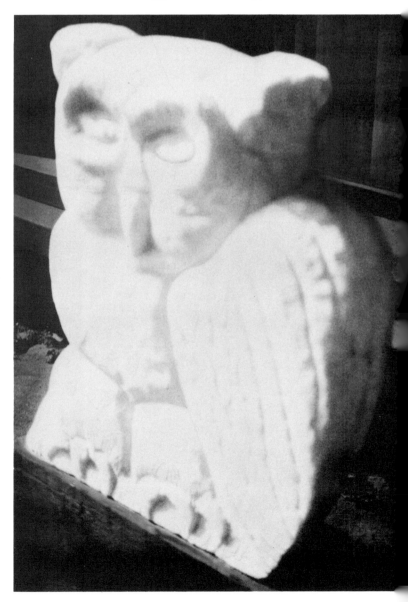

*A revolving modeling stand of
sturdy wood is a necessity.*

Chisel and hammer are used on hard stone.

A penknife can be used on many soft stones.

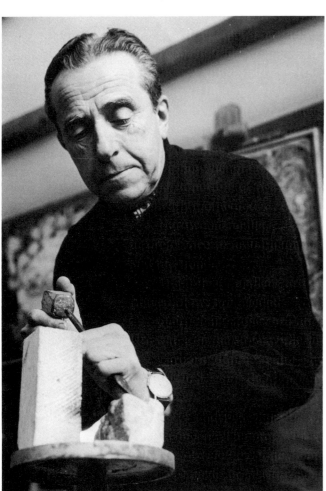

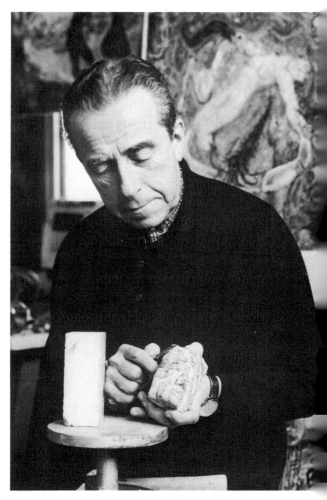

Techniques

Style may be borrowed consciously from sculptors one has admired, or a student may be led toward a particular style through the influence of a teacher. No one is entirely free of the subtle influences of great works, and as long as that influence does not predominate to the point that the individuality of the student is permanently buried, such influences help build the total technical and creative qualities of the student.

The actual techniques of sculpture are as variable as the number of sculptors in the world, but there are certain patterns of procedure that are common to most sculptors and that achieve similar results.

It is the artists' viewpoints and concepts that are responsible for the great separation that makes for individuality in their works.

The way the artist holds the mallet and chisel, the size of the chippings, or the strength of the blows, shows in the surfaces of carved sculpture. The patterns of clay application and the swaths of the modeling tools leave a certain "handwriting" on the modeled piece.

These personal work mannerisms are not teachable. The degree of smooth or rough texture of the completed works is also a personal decision, and it is usually dictated by the theme chosen and the nature of the material used.

Do not seek to develop a technique through conscious effort. It will take its own form through a combination of your creative character and special nervous energy plus the subtle influences on your taste and style to which you have been exposed.

Techniques are also strongly affected by the comparative ruggedness or delicacy of the material used.

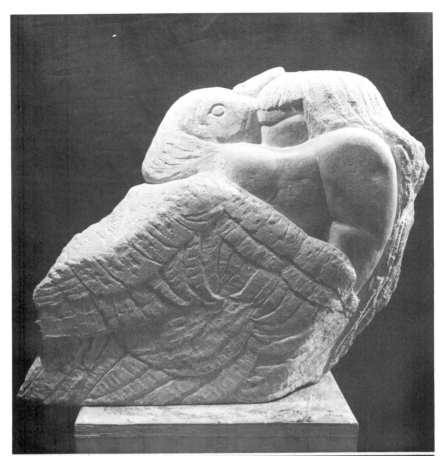

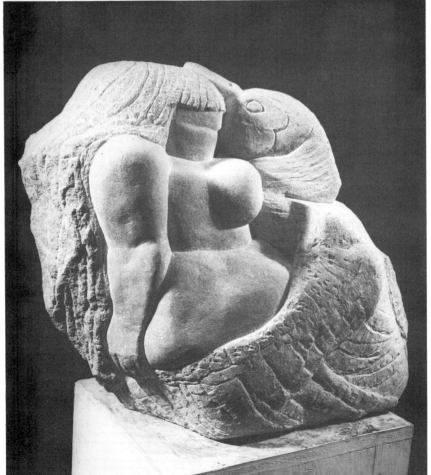

Opposite: Two views of a stone carving by Amy Small.

An example of texture created by chisel marks.

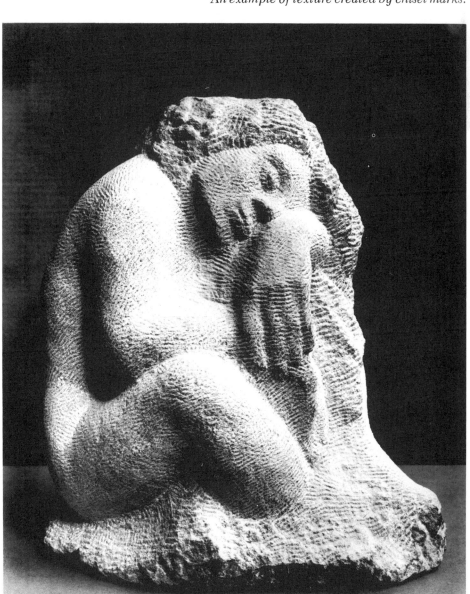

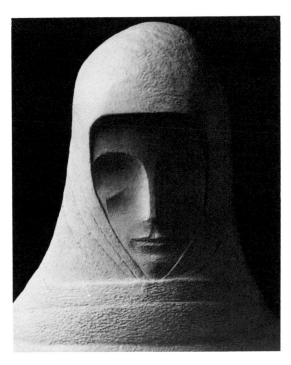

"Lady Poverty," 1949, by Alfeo Foggi. Textured surfaces contrast with simple smooth planes.

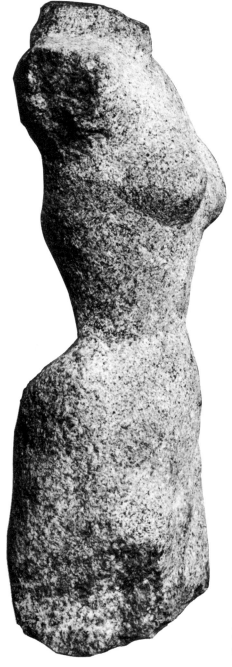

Natural stone markings used to give vitality to a figure.

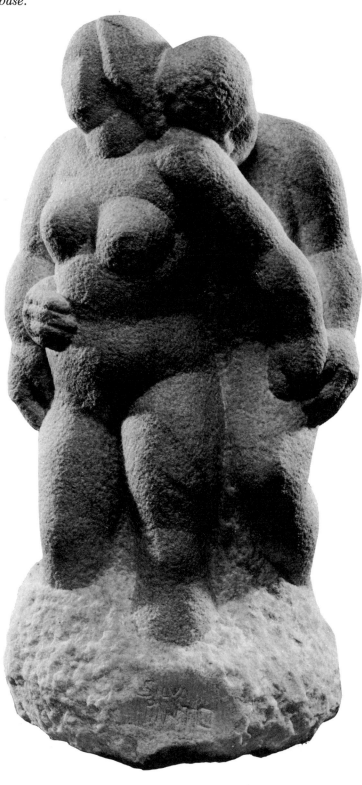

Figures by Cecilia Pinto. Stippled surface contrasted with rough stone base.

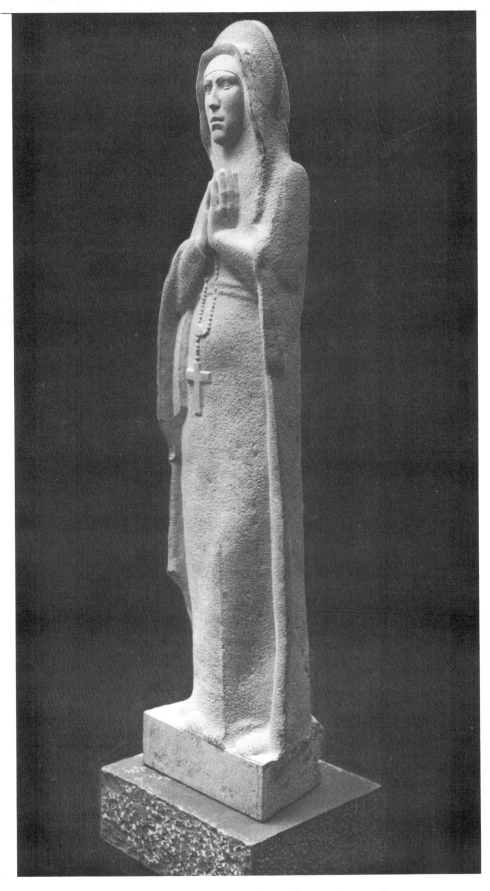

"Our Lady of Fatima," by Tomas Penning. Shows the use of natural texture of stone with very little polishing.

Figure by Hannah Small. Charming use of porous quality of stone as a texture.

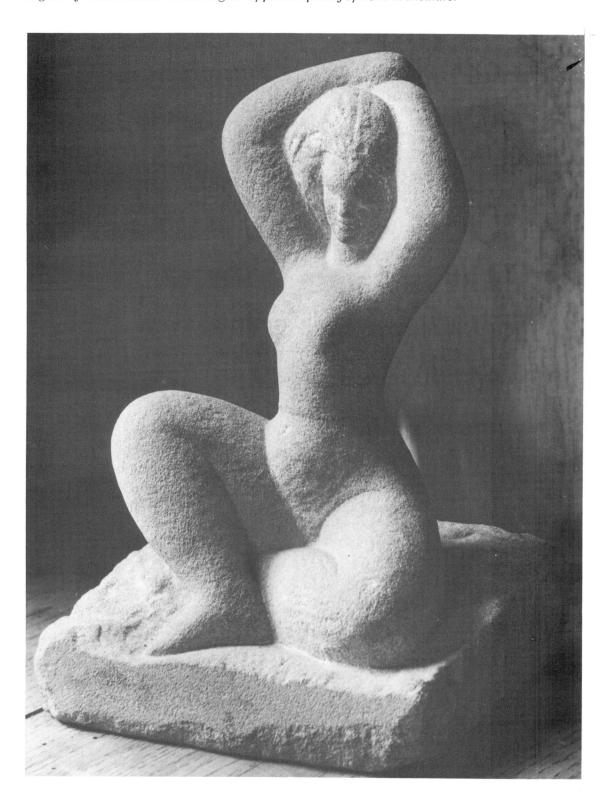

Precious stones

Precious stones have always attracted sculptors who have devoted themselves to carving intricate works of art.

Among the most popular is jade. This stone was and is especially favored by Chinese artists.

Confucius said of the beautiful stone:

It is smooth and shining—like intelligence.

Its edges seem sharp but do not cut—like justice.

It hangs down to the ground—like humility.

When struck, it gives a clear ringing sound—like music.

The strains in it are not hidden and add to its beauty—like truthfulness.

It has brightness—like heaven.

Its firm substance is born of the mountains and the waters—like the earth.

Since the eighth century B.C., the Chinese have revered jade, and out of this somewhat extravagant regard was born an unexcelled skill in sculpting it.

It has a very smooth, hard texture and is very difficult to carve. It is almost as hard as diamond and, even with modern equipment for cutting and with improved abrasives, it requires great patience to work with it. Hand drills are the best tools to use.

The results, however, can justify the struggle.

The colors of jade range from white to dark green to amber. The stone is translucent, with a dull luster. When polished, it has a glassy luster.

It is expensive in rough block form, but most workers in jade do not attempt large pieces. Finished jade pieces command high prices.

The Mayas in ancient Mexico also used jade very effectively.

Agate, less precious and less colorful than jade, has a similar translucency, and beautiful small pieces have been made with it.

Lapis lazuli, another precious mineral that is hard and translucent, has also been used in various parts of the world for carving small pieces.

Less precious but extremely beautiful because of its translucency and soft luster is alabaster. It is relatively soft and may not be exposed to too much dampness or rough treatment. It is not advisable to use alabaster for fine detailed work because it is so fragile.

There are many varieties of quartz all over the world, many of which are suitable for the experimental sculptor. Some are precious, like amethyst, but most are not. Chunks of non-precious quartz suitable for sculpture may be bought for reasonable prices.

Your local builders' supply house probably has catalogues listing the many quartz stones available. Jewelers also often have such catalogues or can procure them.

Dark green jade, Cambodia.

Pre-Columbian jade from Talamanca tribe, ninth or tenth century, Costa Rica.

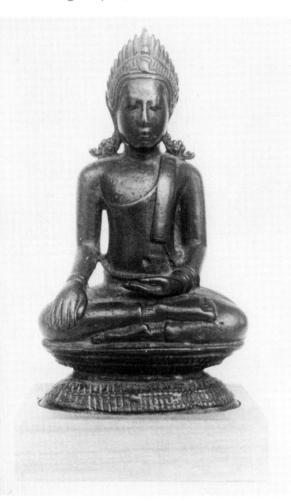

Pre-Columbian jade from Hiroya tribe, ninth or tenth century, Costa Rica.

Rocks

Nature is not an artist. The vast profusion of natural objects, spread with an undiscriminating hand, violates the essential character of art.

A tree is not esthetically beautiful per se.

A natural landscape with its disorderly, chaotic munificence often combines the most clashing colors and has a most eccentric composition.

A rocky coastline or a boulder-strewn plain has no essential esthetic virtue. It requires man — the artist — to choose, formulate, eliminate, discriminate. It is the artist alone who creates art. It is his taste, acquired through his search for beauty and meaning in the birth, life, and death ritual of nature that shaped that quite unnatural concept "art."

Nowhere is the value of the artist's departure from the profitless copying of nature more apparent than in the Far East, in the art of the Chinese and the Japanese. They observed the natural phenomena about them and proceeded to refine and choose in a manner that nature in its blind, mindless confusion of forms could not do.

The results were exquisite works of art, and millions of people exposed to that art began to "see" nature through the eyes of those artists. Concepts of beauty follow the artist's vision.

The Japanese actually strove to change the very character of nature to suit their artistic concepts. It is rare to find a cultivated garden or landscape in which the Japanese artist-gardener has not stunted or twisted trees to suit his taste, rearranged rocks to create desired esthetic effects, replaced natural grass with sand or stone for purposes wholly nonutilitarian in character. Their flower arrangements depart drastically from the natural, their carefully placed pools, which are shaped to express their emotions, in no way resemble the accidental ponds and puddles of nature's creation.

Harvey Fite, sculptor, in his stone quarry.

That the potential for the creation of art lies all about us is clearly shown by the utilization of the materials of nature by Oriental artists.

However, we must employ that potential emotionally and tastefully in the creative process.

It is not always the sculptor's function to carve some recognizable figure or form from the natural rock or tree. Among the great profusion of irrelevant natural objects there lies a vast amount of fine "sculpture," discoverable only by the artist's discriminating eye. In the litter of rocks in a stony landscape lie exquisite "accidents" — beautiful forms waiting for the discerning eye.

Again it was the Japanese, especially, who pursued this artistic activity, this search for shapes that can stand unaltered by the chisel as fine works of art.

Rocks are everywhere. The hunt for the precious ones, precious not in monetary value but in esthetic satisfaction, is as rewarding as prospecting for gold.

In many homes in Japan one may see stones of boulder size, polished or rough, craggy or smooth, to suit the special tastes of the owner. They are often set on a free-form block of wood, which serves as a base. These stones are prized as highly as a fine piece of cut sculpture and are sometimes of considerable monetary value.

Art galleries display such natural "art-accidents" and put high prices on them.

Search your backyard and neighborhood countryside for beautifully shaped rocks. You will soon find that there is much pleasure to be found in the search and more in the discovery of a dramatically shaped stone. Some are so fine in their virgin state that to touch them with even the most skillful sculptor's chisel would be an act of sacrilege.

Metal

Welding

The use of welding as a direct metal sculptural process has become widespread.

Metals once were used only by the foundries for casting sculpture previously modeled in clay. But now welding allows the vigorous sculptor to express himself in the virile medium of iron or steel without the intermediate steps that tend to blunt the vitality of the artist's inspiration.

Welding equipment is available in sculpture workshops and is also procurable for home-studio use at not too excessive costs.

When the beginner-sculptor wants to try welding but does not wish to invest in the cumbersome tanks and tools and there is no sculpture-school in his area with such equipment available, the local car-body repair shop might be approached for the rental or loan of the necessary equipment.

The welding process is not as complex and forbidding as the sight of the welder at work might make one think. His mask plus the white-hot, spurting flame of the welding torch could tend to put off the timid at first. However, many women sculptors have adopted this medium. Muscle and male daring are not necessary. With reasonable care in the handling of the torch and normal precaution against accidents, there is no reason why anyone cannot use this intriguing procedure to join metal to metal.

There is now available for sculptors' creative efforts a huge store of junk metal, which is part of the scene in almost any town as a result of the mechanical age in which we live. This by-product of industry lies fallow, waiting for the artist to reassemble it into images unlimited by any restraints other than those of his imagination.

Ingots, sheet metal, twisted scrap, or bars of steel may be modeled, forged, and bent into any shape desired with the power of the melting flame of the welding torch.

Many fine sculptors have been attracted to the technique of welding sculpture, with the result that monumental works of extraordinary power have been created.

133

Notable among these are the dynamic, rugged constructions of David Smith, who worked with raw masses of iron or steel.

Picasso has welded tools, engine parts, and other "found" objects of metal together into animal sculpture of great wit and power.

Another Spaniard, Julio Gonzalez, was one of the great forces first to work in welded steel and iron. Seymour Lipton, Edward Chavez, and Lynn Chadwick are among the many fine artists who have been attracted to this medium.

Lynn Chadwick is a brilliant inventive "original." He works in relatively solid forms; no holes or undercuts disturb the walls of his pieces.

Chadwick welds construction skeletons, or "cages," of iron tubing and then fills the open spaces with iron sheeting, allowing the ribs of tubing to show. Together they form walls like the patterns of a duck's webbed feet. He introduces cement to the metal walls to lend a vitalizing patina.

Some of Chadwick's tanklike creatures resemble prehistoric birds and animals that might have been manufactured by Krupp. Others of his works are of men and women, geometrized and featureless but conveying a strangely compelling humanity.

Metal melters

Most frequently, sculptors employ the expert services of art metal foundries for the casting of sculpture in metal.

However, small metal-sculpture casting is being done in schools and private studios in crucibles using electricity or gas.

Large sculpture supply houses issue catalogues of price lists and booklets of instruction in the use of these small crucibles.

Plating metal sculpture

Many sculptors in iron or steel like to refine the surface of their works with a thin film of gold, silver, chromium, copper, or any of a number of other high-polish metals.

This is done by a commercially developed process called electroplating.

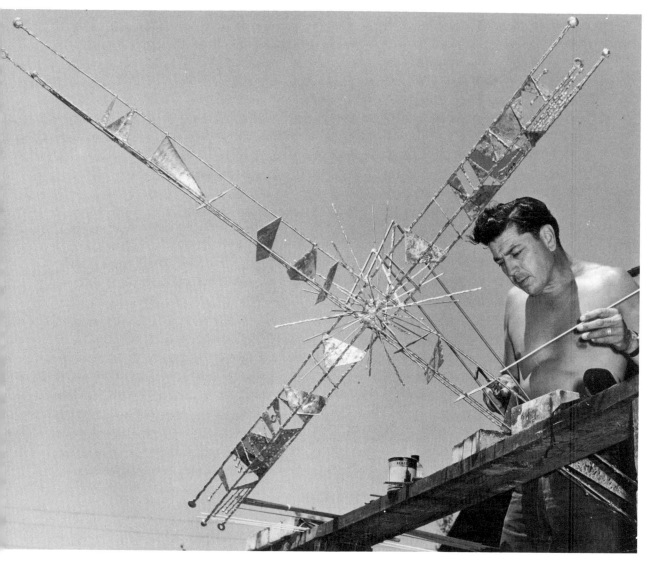

"Cross for Episcopal Chapel" by Edward Chavez. A steel, silver, and copper welding.

The process involves the immersion of the iron or steel piece in a tank containing a solution of the plating material. An electric current is passed through the plating solution, causing a thin film of plating to adhere to the base metal.

It is a complex procedure for the beginning sculptor. Although the artist should also be a craftsman and understand technological problems, he should not hesitate to take advantage of the facilities of well-equipped and trained technicians.

Take your sculpture to a commercial electroplater. It is as legitimate to do so as it is to go to a commercial foundry for casting large pieces in molten metal.

135

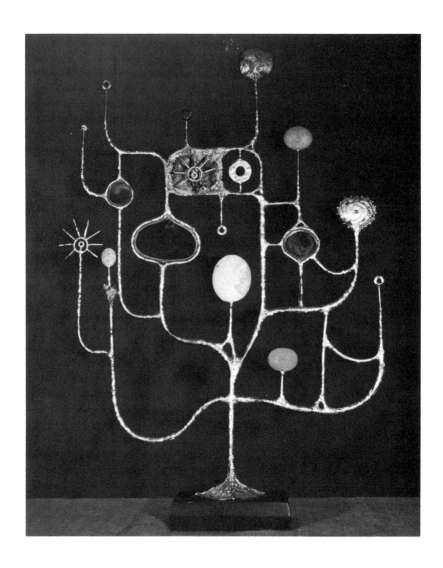

Patinas on metal

Patinas are surface treatments applied for the purpose of covering the raw newness of the metal.

Some workers in metal choose to score, etch, incise, burn, mark, or otherwise change the texture of the surface of their sculpture.

This may be done with acids, blowtorches, files, or hammer blows. Iron and steel are not as unyielding as one might think.

The addition of patinas other than the natural ones of the metals used is subject to the personal taste of the artist, and whatever means he uses to achieve his objective are permissible.

Rust and corrosion, though undesirable in machine parts, often give a rich, warm quality to metal scultpures.

Such effects may be obtained by burying the metal in earth until the desired discoloration is obtained.

Exposure to weathering also often produces the patina desired.

Opposite: "Rain Forest" by Edward Chavez. Welded and brazed bronze on copper and stained glass.

Soldered metal. "Pegasus" by Edward Chavez.

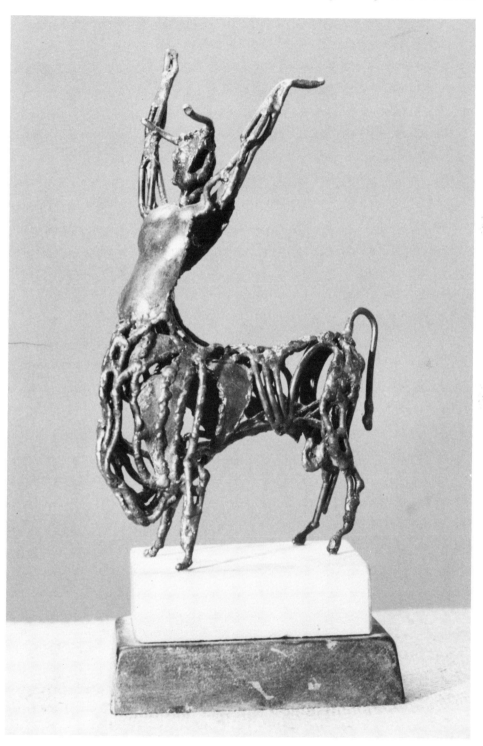

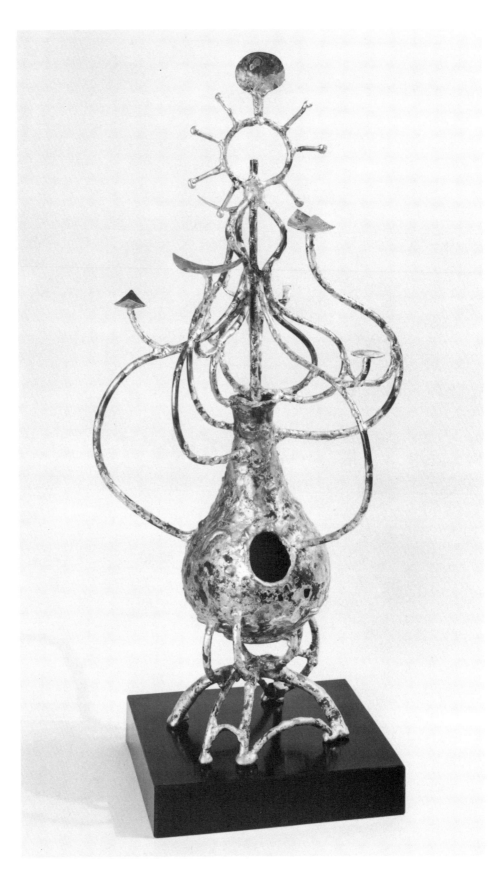

Soldered metal piece by Edward Chavez.

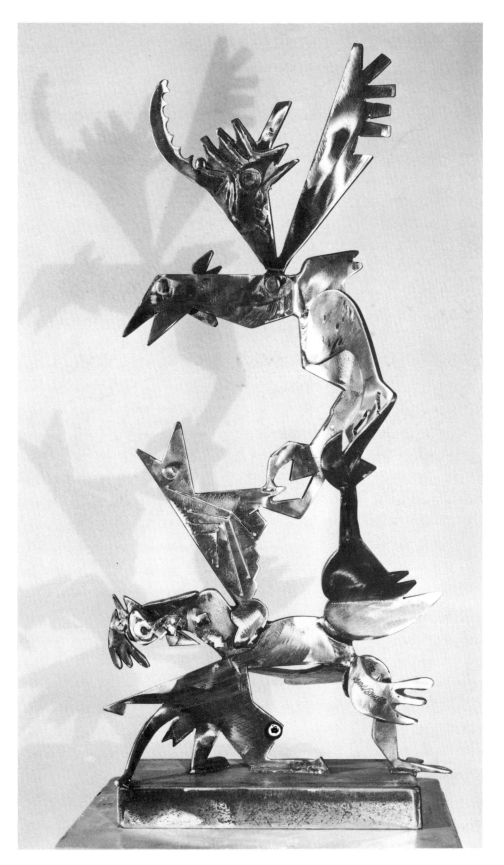

Steel. "Cockfight — Variation," 1945, by David Smith.

Iron. Untitled, 1961, by Julius Schmidt.

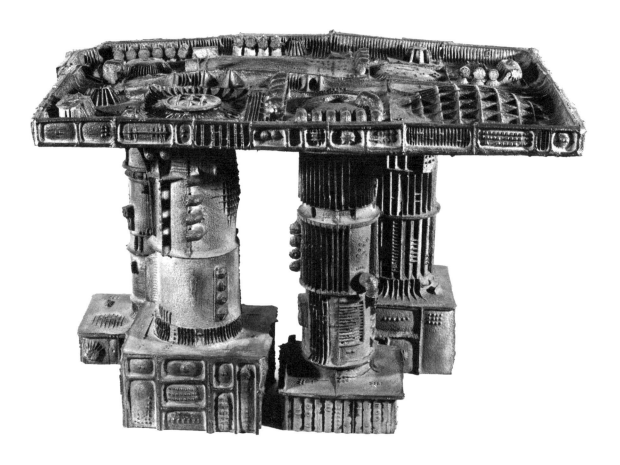

Chrome-plated steel. "The Anatomy Lesson," 1962, by Jason Seley.

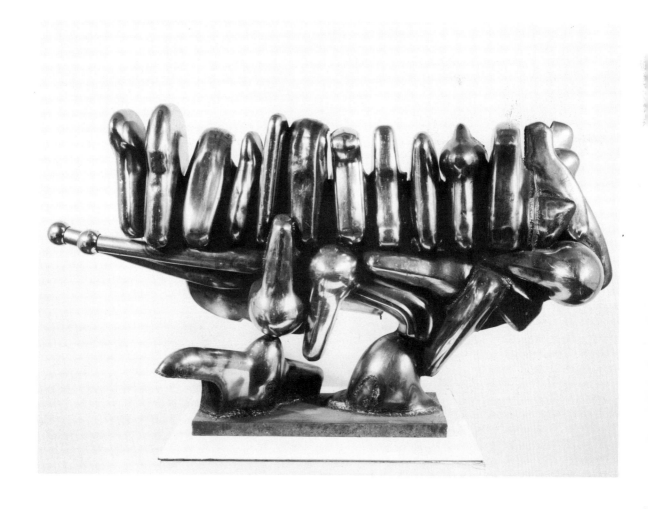

Opposite:
A bronze charioteer by Giacometti.
Three examples of this were cast.

Soldered sculpture by Alexander Ross.

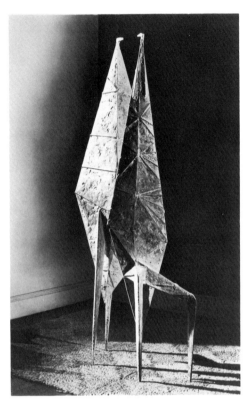

Bronze. "'Harp Player II," 1960, by Bernard Reder.

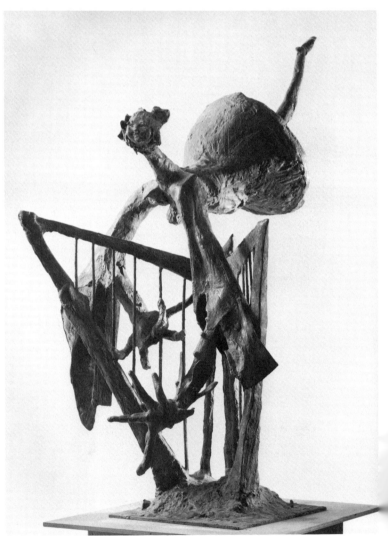

"Encounter VIII," 1957, by Lynn Chadwick.

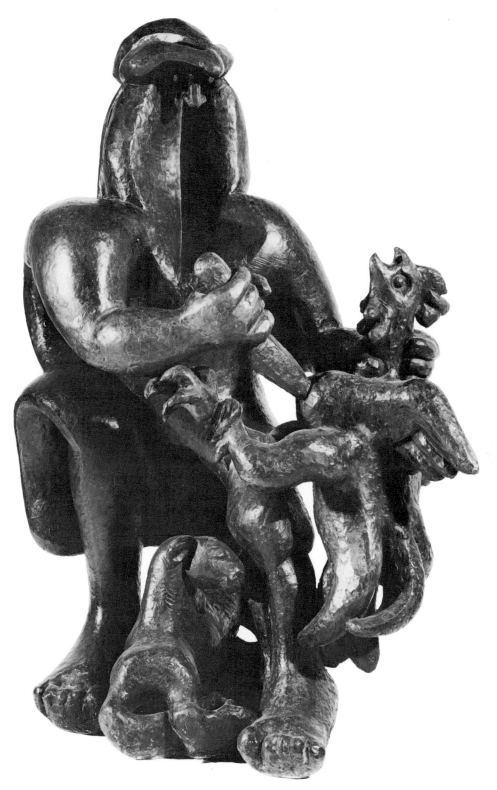

Bronze. "Sacrifice II," 1948–1952, by Jacques Lipchitz.

New materials

Artists have always been highly influential in revising the appearance of the man-made world and even in affecting our vision of the natural world.

Mondrian's patterns have subtly changed the appearance of most of our buildings, furniture, clothes, and even kitchen utensils. Picasso has even had an influence upon the way one sees one's fellow human beings.

Contemporary sculptors have given us a fresh viewpoint, revealing to us new "sermons in stones" and the esthetic delights to be found in scaffolding, in junk yards, and in mechanical parts of complex machines.

Here are some of the innumerable combinations of materials used by contemporary sculptors in the execution of their sometimes brilliant, sometimes witty, often merely daring or different, but always interesting, creations.

Richard Stankiewicz has used lengths of chain and steel.

Edward Higgins combines steel with epoxy.

Mark di Suvero uses wood and steel together.

Lee Bontecou works in canvas and steel.

Marisol mixes wood, steel, and many other materials, painted or carved to achieve her imaginative pieces.

Lucas Samaras has combined colored wools with innumerable protruding pins. Another of his works is made of rope and pins. Still another piece is composed of two spoons set in an aluminum and wire base.

Joanna Beall combines wood, nails, and mirror glass.

Anthony Padovano works with steel joined by lead pipe.

James Melchert uses aluminum, wood, and lead.

John Chamberlain uses crushed auto-body parts of various colors.

Jason Seley welds gleaming auto bumpers into massive shapes.

Edward Chavez has made beautiful pieces using nothing but wedge-shaped three-inch nails soldered together.

Many daring sculptures made of canvas, burlap, rubber, and plastics of every variety and color have appeared on the gallery scene.

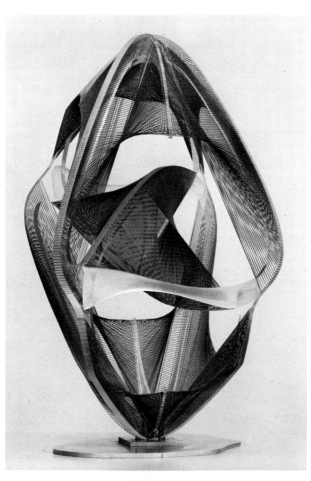

Plastic and stainless steel. "Linear Construction in Space, No. 4," 1958, by Naum Gabo.

Fiberglas, wood, masonite, and flakeboard (13 feet in diameter, 7 feet in height), untitled, 1968, by Jack Weisberg.

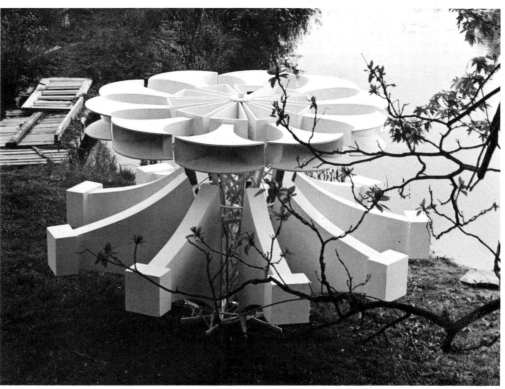

What is art?

A good many years have passed since Brancusi was challenged by customs officers when he brought from abroad his beautiful soaring abstraction in brass. They refused to recognize it as a work of art and demanded that he pay duty on importation of bulk brass.

The world has now become accustomed to the vagaries of modern artists, and the day may not be far off when a freighter loaded with pig iron will enter New York harbor and claim exemption from duty on the grounds that its cargo must be considered as deathless art — and perhaps with some justification!

Beauty and drama often lie in the "happening" of ingots of metal stacked high or the crushed car in a junkyard. There are no arbitrary criteria available as guides to what are great, good, or bad art works. The only trustworthy sources of judgment lie in thoughtful and honest responses to work that reveals thoughtfulness, honesty, and emotion on the part of its creator.

We are all inevitably influenced by current fashion and success. If such art trends do not show the crude hand of the publicity hound and the poseur, there often exists valid reason for acceptance by the art public. Time and taste soon expose the palpably fraudulent.

The current art scene angers many, horrifies others, and brings amusement and pleasure to still others.

For your own instruction and to help you in making ultimate judgments, become a constant gallery-goer. Subject everything you see to judgments as free as possible of a priori prejudices (we all have them), and give yourself the fullest opportunity to derive the greatest amount of pleasurable esthetic experience and emotion.

That which you see will inevitably, subtly influence your own work. If that influence is not motivated by the "market" or by the desire to shock, it will be valid and valuable.

Vinyl, wood, and kapok. "Dormeyer Mixer," 1965, by Claes Oldenburg.

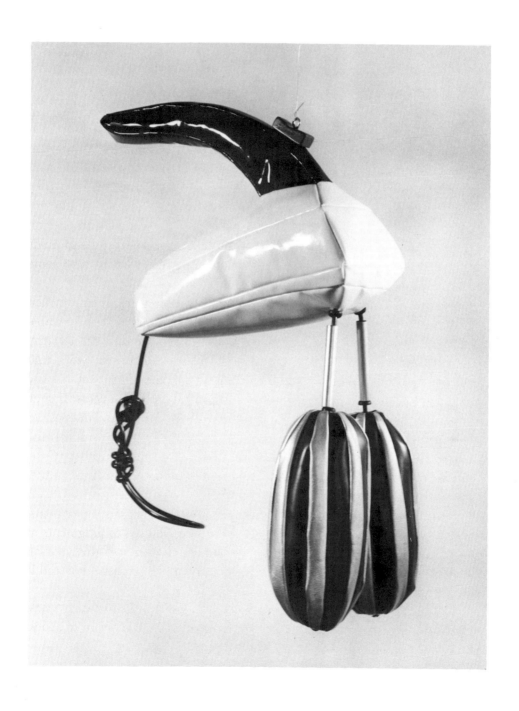

Mobile by James Turnbull.

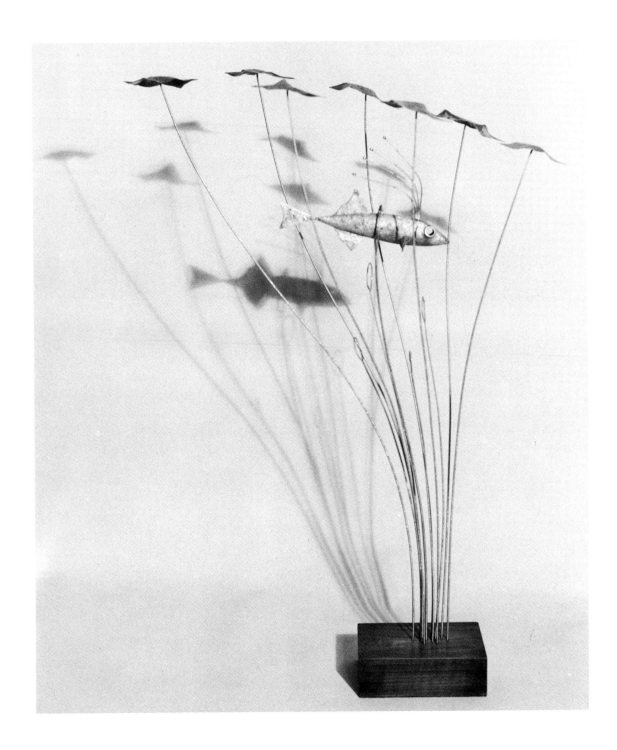

Mobiles

The tinkling arrangements of small pieces of glass that were once popular as amusing decorations hung in the parlor were among the first mobiles. They were delicately balanced so as to move "musically" with the slightest breath of air. They were not made from a conscious creative impulse as "works of art," but many were quite beautiful and the balancing called for considerable ingenuity. They did not reach out daringly in their balances, depending instead on symmetry throughout. They were usually arranged in a circular or square pattern.

Another commonplace mobilelike contrivance, utilizing balance and air currents, is the kite, an ancient plaything used throughout the world. Orientals are known for their highly complex and decorative kites, which combine beauty with a knowledge of aerodynamics.

Kites made in Bangkok show much inventiveness and beauty in their design. They are so maneuverable that contests are held between girls and boys who fly "fighting" kites, which are designed to bring opposing kites down. High artistry is often to be seen in the design of these kites.

However, the concept of moving sculpture had to wait for the development of very strong but pliant metal and durable nylon thread before more permanent, daring contrivances than balanced glass hangings or kites could be created.

The invention of strong, supple metals and plastics gave the resourceful sculptor the opportunity to create bold thrusting arms balanced by counterweights dangling from suspension points. As is the case with so much of modern sculpture, the technology of industry produced the wherewithal for the free play of the artist's imagination.

The first artist to transform mobiles from the merely decorative or playful into art was Alexander Calder.

He departed from the use of earthbound clay, wood, and stone, and soared into the "air age" of sculpture with great wit and fantasy.

Utilizing space around his exquisitely balanced, dancing designs of weights and counterweights as an essential ingredient to enhance the whole, he gave movement an artistic meaning, adding a new element to the previously static world of sculpture.

The process is simple, and the results are as personal as the individuality of the artist. The principle in making mobiles is similar to that of the old-fashioned grocer's scale, which used weights and counterweights. Suspended from the ceiling is the center pivotal cord or wire upon which the balance is to be created. Every projecting form affixed to this pivot must be counterbalanced. A long thrusting arm of metal may be countered by a short opposite one, but the latter must have greater weight to compensate for its shorter length.

From each thrusting form that departs from the center of verticle suspension may be hung or affixed many lesser forms. Each must be compensated for in order to maintain the balance.

Movement, the quality implicit in the word "mobile," is achieved by the stirring of air around the delicately attached "arms." To facilitate this movement, "sails" are used along with the metal arms. These sails are dangling shapes of metal, plastic, or whatever medium the sculptor wishes to use. They are of various widths, although greater than that of the arms from which they are suspended. They are intended not only to catch the air currents but to be an intrinsic part of the sculpture's design.

Many mobile artists use color in their forms. This adds to the kaleidoscopic dancing quality so characteristic of mobiles. Others prefer to use only gleaming metals, which catch the light brilliantly as they gracefully move.

The rewards of experimenting with this delightful medium of sculpture lie in two directions. Either the experiments will result in mobiles of genuine quality, or the mere experimentation will add the qualities of balance and lightness to your stabile sculpture. Not to be classified as true mobiles but partaking of the vitality given by movement, stabiles are stationary sculptures, made of pliant metals so that they sway with the breeze. Balance of weights is not the essential structural approach.

A splendid series of such mobile sculpture has been created by James Turnbull. In recent years, Turnbull has been using long brass and copper rods that move in graceful rhythm to enhance his witty sculpture.

Gold-filled wire, 22 karat. "Variation within a sphere,
No. 10: The Sun," 1956, by Richard Lippold.

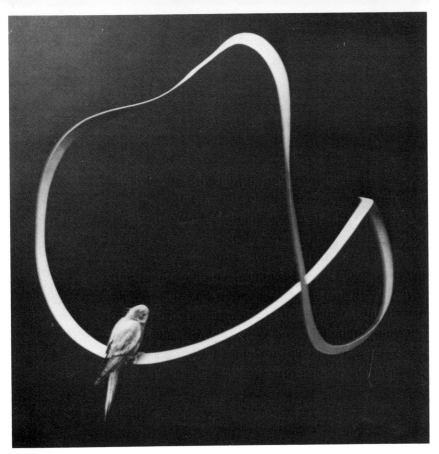

Thin, twisted plywood...
by John McClellan.

"Meta." Metal and wood
mobile, 1967, by John McClellan.

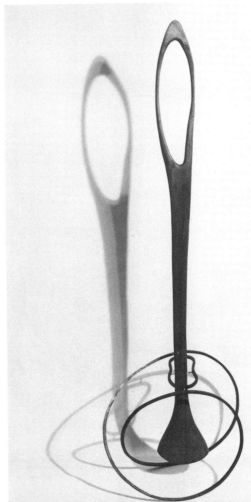

154

Kinetic sculpture

At the 1967 Biennale Exhibition in Venice, a show of international scope, the exhibit that won first prize was a large metal piece of "kinetic" sculpture (although it was awarded the first prize as a painting).

The exhibit required the viewer to wear special eyeglasses in order to appreciate the work's virtues properly.

This painting-sculpture piece is the work of Julio le Parc, an Argentine artist.

It is made of metal, polished to a high sheen, which reflects the beholder. He may manipulate a pedal that sets the parts of the metal sheet into a series of motions, which distorts the reflected image.

Similar kinetic sculpture has intrigued considerable numbers of artists.

The idea of making the beholder of a work of art a participant in its "life" should stimulate the inventiveness of sculptors.

Many ingenious methods of propulsion are available for experimental use in animation of hitherto static concepts.

Serious artists, bent on creating fresh images to express their artistic concepts and not merely intent on being different, may find much to interest them in exploring the rich possibilities of kinetic sculpture.

Here follow four examples of kinetic sculpture which will serve to demonstrate the effort on the part of the sculptors to expand the esthetic sensation of the viewer.

The first two photographs are of sculpture pieces made of hand-twisted copper tubing turning at the rate of one complete revolution per minute, powered by small, geared electric motors. John McClellan, the sculptor, points out that the moving shadows cast by the turning structure execute ever-changing arabesques on the walls and floor and these become part of the sculptor's concept.

The next two examples of kinetic sculpture are made of neon and Plexiglas. They are powered by electric current and the gleaming light adds dimension to the writhing tubes of glass.

Copper tubing (approximately 20 inches), gear motor driven (1 rpm), mahogany housing. "Kinetic construction #1," 1968, by John McClellan.

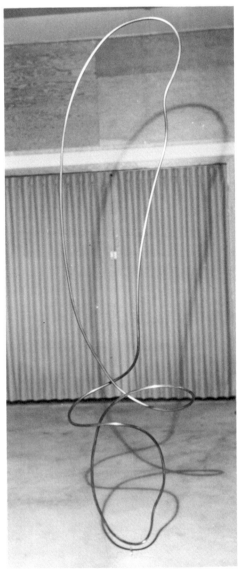

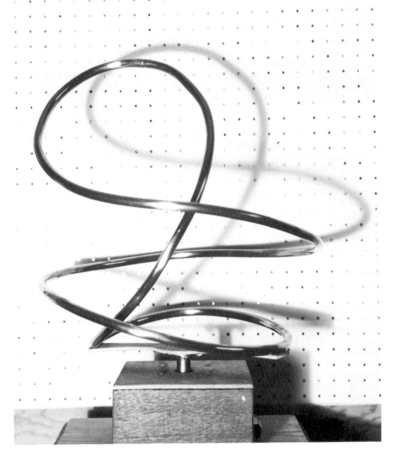

Copper tubing (8 feet), gear motor driven (1 rpm), "Kinetic construction #2," 1968, by John McClellan.

Power-driven sculpture

One school of kinetic sculpture has evolved a variety of intriguing and sometimes very dramatic creations made of motor-driven movable parts.

Some are powered by windup action, others are battery driven, and some are plugged in to electrical outlets.

Such action sculpture is not entirely new. For hundreds of years European craftsmen have contrived finely sculptured figures that revolve at certain hours around town clocks or dance daintily to the tunes of music boxes.

The modern kinetic sculptor, however, rarely seeks to make his works emulate human action. His moving-parts sculpture is designed with the purpose of adding a dynamic dimension to his construction. The action built into his sculpture is intended to be as abstract as the physical nonobjectivity of the piece.

Permanence is not necessarily a virtue in all such sculpture. Some have been contrived to be self-destructive, designed to disintegrate before one's eyes. Mercifully, in my opinion, the loss is not too great to posterity.

Still another variety of sculpture that should be included in the "moving school" employs flashing lights built into the piece. The lights are sometimes arranged so as to be adjustable to suit changing moods and whims. Some of these works are highly imaginative. This school is still in its early stages and it offers a challenging field for creative experiment to the adventurous student.

Not strictly in the category of movement but characteristic of the search for dramatic immediacy in sculpture are the "sound-effects" sculptures, which emit periodic bell or buzz tones, beeps or drumbeats, murmurs or explosions of sound. While most sound-effects works are merely superficial efforts to be different, the combination of sound with the sculptural structure has a legitimate *raison d'être*. In a way it is as valid as the sound of wind in

the trees and the murmuring of brooks.

Many of the foregoing experiments in movement, light, and sound may strike the reader as being facetious and superficial attempts to attract attention and thus not worthy of a serious sculpture student's study.

If the descriptions of these new approaches to sculpture have added to that impression by seeming to treat such work with small respect, I should like to point out that, though most of these way-out approaches are of an exhibitionistic nature, this does not invalidate experimentation with these approaches. Bright, witty, and compelling things have been done by some of these new schools, and further delving into the creative qualities possible in these daring media of expression is definitely warranted.

Free-standing neon (51 x 29 x 39½ inches). "Study for the gates #14," 1967, by Chryssa.

Neon and Plexiglas (43 x 34¹⁄₁₆ x 27¹⁄₁₆ inches). "Fragment for gates to Times Square II," 1966, by Chryssa.

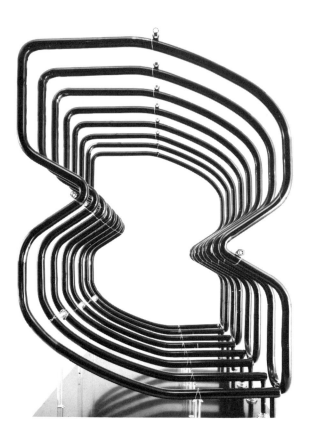

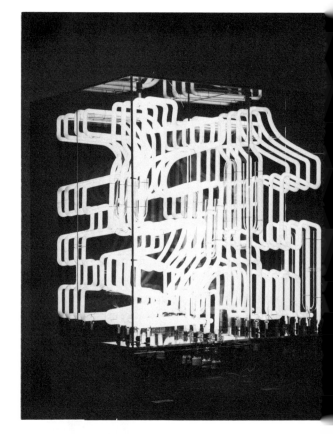

Art is where you find it

Artists of the past have rarely involved themselves in the practical world of the production of necessities.

The only participation permitted was the relatively superficial "decoration" of commercially produced objects, and that was done apologetically, with the excuse that an artist must eat.

In recent years, however, sculptors of repute have used their talents for the design of industrially produced items such as radio cases, toasters, potato peelers, and so on. Excellent artists of Sweden have designed spoons, knives, and forks, as well as chairs and percolators. The Museum of Modern Art in New York City has presented a huge show of such artists' participation in the design of practical objects.

But it is only lately that appreciation has evolved for the tools and appliances that were the products of craftsmen who were not consciously artists. With the appearance of new metals, plastics, and new techniques requiring new tools, the metallurgists and toolmakers have developed gleaming works of art that had no esthetic impulse behind their production. With a minimum of waste in design, with the only criterion being their ability to do the job assigned, tools and machines with an artistic validity equal to most of the conscious art works of any time have evolved.

Wrenches and pliers sometimes have the exquisite purity of design of a Noguchi, Arp, or Brancusi sculpture. Machines and engines, though highly complex, have the beautiful economy of design that conveys the sensation produced by David Smith's powerful structures in welded steel.

Television antennae in gleaming aluminum form delicate traceries and beautiful balances comparable to the delightful lyricism of Calder's mobiles.

This song of praise for the utensils, tools, and machines of our time does not imply the replacement of conscious artists by toolmakers but rather the

interplay between the two worlds to the benefit of both. Our interest here is to alert the young sculptor to the beauties of objects around him. Art is truly where you find it.

John Flannagan, the excellent sculptor in stone and wood, spoke of the "often occult attraction in the very shape of a rock as a sheer abstract form." On the other side of the world, in Japan, contemporary department stores in Tokyo have whole counters devoted to the sale of stones in their untouched, natural shapes. Deeply involved purchasers examine the stones' facets with the excitement of the dedicated art collector.

We all react to the sometimes highly dramatic convolutions of driftwood and roots. Almost every tree has within its intertwined branches the elements that the discerning eye of the art lover can "construct" into valid sculpture.

The obvious enrichment of the esthetic life by the development of the enjoyment of "found" art need not stop with the beholding of these things of inherent beauty and power. The adventurous sculptor may use his artistic inventiveness in contriving sculpture utilizing the natural found art and his own craftsmanship to produce works of striking originality.

Modern powerful epoxy glues have allowed sculptors to "weld" stone to stone. Innumerable joining techniques have evolved, which may aid the searching artist in his delightful game of creation.

Tree branch — "found" sculpture, Arthur Zaidenberg.

Feelies

The tactile pleasures to be experienced in connection with sculpture are not to be found in any other art form.

Museum guards are constantly called upon to deal with the "touchers." The urge to run one's hands over the cool surfaces of a piece of sculpture is almost uncontrollable.

There has come into vogue a new school of sculpture that exploits this urge creatively.

"Feelie" shows are exhibiting pieces aimed toward both the viewer and the toucher.

Both soft and hard objects of innumerable textural variations invite the sensitive fingers of the gallery visitors.

Small pieces have also been designed to give pleasure to both the senses of touch and of sight. These works are often carved from smooth stone of a size suitable to be held in the palm and "played with," so that the cool contours of the pieces are enjoyed along with the beauty of the shapes.

Part of the feelie school of sculpture is the found-object, natural-state shape. Smooth stones of various textures and shapes, small enough for the pocket and the palm of the hand, are treasured objects in many collections.

As has been pointed out, a stone does not necessarily require the sculptor's chisel to become a work of art. What is required to so designate it is the recognition of the artist or art lover.

Jade sculpture from Costa Rica (slightly enlarged).
Its smooth, cool surface makes it pleasant to handle.

Wire sculpture by Amy Small.

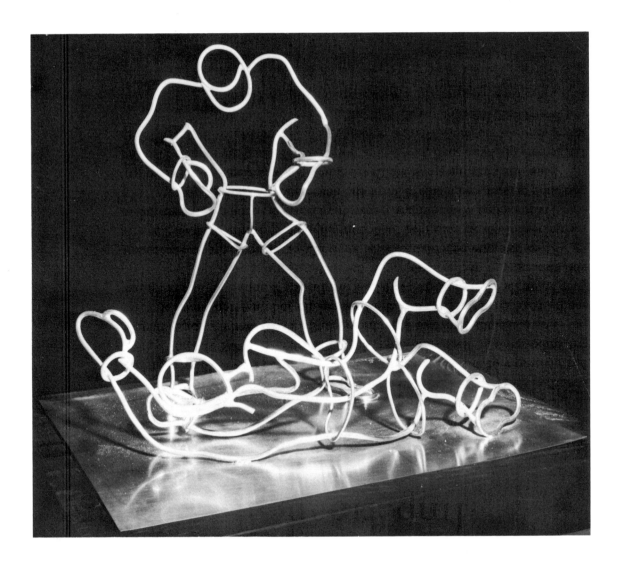

Impermanent sculpture

Not all of us work for the ages. Many contemporary artists feel that posterity will take care of itself and that the passing pleasure of the immediate public is sufficiently rewarding. The celebrated case of the self-destructive sculpture piece in the garden of the Museum of Modern Art in New York City is an example of at least one artist's scorn for the admiration of generations yet unborn.

There are other factors to consider, while working in the impermanent media, than those of scorn for the future public and deathless fame.

These factors are the relative ease of working in such media of sculpture and the low cost and availability of the materials used.

Soap for carving small figures is ideal for amusement and practice. Large bars of cheap soap may be bought anywhere for little money. Carving them requires no more than a penknife. The nonresistant soap still offers the same creative problems of form and space, judgment and taste.

Fine work has been done with soap, notably by Gabo.

Paper sculpture

Gabo also has created paper sculpture of considerable ingenuity. Using paper of some body and tensile strength, he shapes and glues figures in planes and spatial relationships not easily obtained in media less tractable.

Japanese origami sculptors fold and model paper into exquisite shapes. They have popularized paper sculpture enormously all over the world through the sale of kits and instruction books on the subject.

Much can be learned from such work that may then be applied to more ambitious efforts in sculpture.

Wire sculpture

Though wire is not as perishable a substance for sculpture as paper, it still must be considered as an impermanent medium when thin, light-gauge wire is used.

"Line drawing" in sculpture is possible in wire. Lead wire of considerable pliancy, yet firm enough to support itself over reasonable expanses of space, is obtainable in most hardware stores. Wire benders are also available. These are metal bases with short protruding posts. Screwed to a worktable top, these posts serve as fulcrums for twisting strong lead wire into desired shapes.

Fine "line sculpture" has been done by many sculptors, notably Hunt Diederich. Pete Turnbull has made many subtle caricatures in light-gauge wire.

Butter, sugar, and ice

Carrying impermanence to the extreme are the creations of master pastry chefs and ice carvers.

Though still not tapped as an artistic "find" by the Museum of Modern Art, the delicate traceries of Viennese and French pastry artists often reach heights of lacy beauty not often seen in other media in our present-day art world.

Ice sculpture, the most transient of the sculpture media, is not recommended except for two main reasons.

The first is that it is a material that offers the least resistance to the sculptor's chisel and yet provides an excellent practice range for bold shaping in broad planes.

The speed possible in — and required by — this smooth-chipping material may serve as fine training for the more durable but more resistant stones and woods.

Another, more practical, reason for working in ice is that there are highly paid jobs available on ships and in great hotels to the dwindling few who still practice this art.

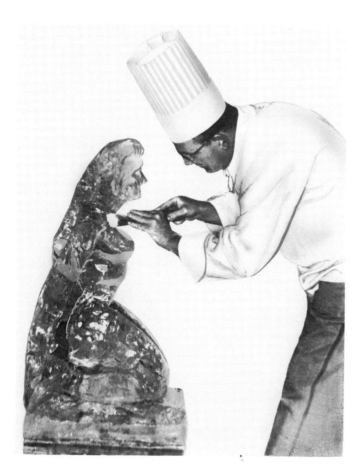

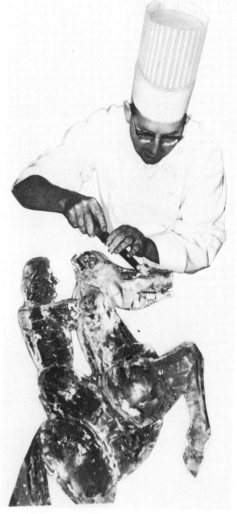

Ice sculpture by L. C. de Bruin.

Plastic metals for modeling

There are several plastic metals on the market with which sculptors may model in the same manner as they would clay or terra cotta.

These plastic metals require no firing or casting to acquire permanence. When allowed to dry (they are kept in a puttylike state by solvents while in the tube or can), they harden into a firm metal of dull gray color.

Burnished or scored with a rasp or an electric sander, the metal may be made to shine.

The use of this plastic metal requires armatures underneath very much like those made for clay models.

Apply the plastic metal in pellets kneaded with the fingers to the required size.

A liquid solvent is also procurable for these plastic metals. The solvent may be used to help keep the material in its pliant state during the progress of the piece.

The solvent also may be used to dissolve particles of the metal that dry on the modeling tools and on the fingers.

Some fine small pieces have been made with these synthetic metals, but it is not recommended that they be used for very large pieces. The material is relatively expensive and its adhesive qualities are not strong enough for use in very heavy areas of sculpture. To help support fairly large expanses of the metal, wire mesh should be added to the armature tubing.

Opposite top: The author at work on a plastic metal figure.

Opposite bottom: Liquid metal poured over a clay figure.

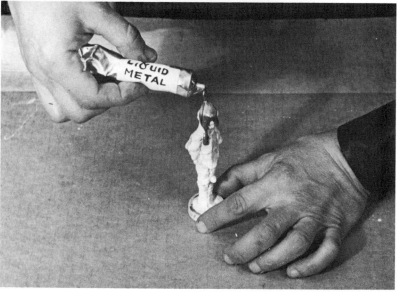

Solder sculpture

The once humble soldering iron, now electrified and sold in any hardware store, has become an important adjunct to the metal sculptor. It is also a direct sculpture tool on its own and, along with a spool of solder wire (solder may also be bought in stick form), strong pieces, durable and unique in character, may be modeled.

The process is among the simplest of the sculpture procedures.

Flux, an adhesive preparation, is sold in small cans or tubes. It is applied to the wire armature upon which solder sculpture is to be done.

When the armature has been twisted to its required skeletal shape and the flux has been applied (with a brush or the fingers), the application of the solder is accomplished in the following direct and simple way.

Hold the length of solder wire or stick in the left hand, the plugged-in soldering iron in your right, and, carefully controlling the drips of molten solder, start to build up the figure on the armature.

With just a bit of practice you should develop control to the point that each small drop of solder will fall exactly where you want it.

Keep a sandpaper block handy to remove excess cooling solder from the beveled edge of the soldering iron.

Liquid solder

Tubes of liquid cold solder are available in hardware stores.

Liquid solder is of sufficiently fluid quality to enable the sculptor to pay the solder directly out of the tube to form a smooth metal cover over the rough drips of melted solder from the iron.

Liquid solder also permits a metal coating to be administered to a hardened self-setting clay sculpture.

As the thick fluid oozes from the tube, gravity will cause it to flow evenly down the figure, producing a smooth coat of metal over the clay surface.

Tin and solder sculpture by Amy Small.

The "art game"

Symptomatic of the challenges of our swiftly changing, unsettling times are the daring young innovators on our art scene.

Impatient with any restrictive categorizing, many of these young artists are eliminating the boundaries between painting and sculpture. They frequently create three-dimensional painting or combinations of solid forms with flat, painted surfaces, ruthlessly abolishing barriers of conventional classification in order to better express their far-out concepts — and sometimes they succeed in saying something of value with their unconventional approaches.

One such departure from the commonplace is the recent introduction of the "art game," in which the artist's creation is subject to the owner's rearrangement and esthetic "play."

This "audience participation" idea calls for the creation of a stimulating combination of movable forms and shapes, conceived not as an immutable entity but as a vehicle of infinite powers of expression.

Oyrino Fahlstrom, a Swedish painter-sculptor, contrives such variable art-game concepts. They are made up of many dissimilar parts — flat objects, metal boxes, metals, paper, etc. He arranges these incongruous objects to suit his fancy, but invites the purchaser to reassemble the pieces to suit his own tastes.

Where to obtain the conventional and new tools and materials for sculpture

The following sculptors' supply houses will mail catalogues on request.

Arthur Brown & Brothers, Inc., 2 West 46th Street, New York, N.Y. 10036

The Craftools Co., 1 Industrial Avenue, Woodridge, N.J. 07075

Sculpture Associates Ltd., 114 E. 25th Street, New York, N.Y. 10010

Sculpture House, 38 East 30th Street, New York, N.Y. 10016

Sculpture Services, Inc., 9 East 19th Street, New York, N.Y. 10003

Smith Carbonic & Oxygen, Inc., 421 East 75th Street, New York, N.Y. 10021

Stewart Clay Co., Inc., 133 Mulberry Street, New York, N.Y. 10013

Picture credits

page 17: Courtesy of Mrs. Fernand Leval. *pages 18, 20, 21:* Photographs by John Mulder. *page 44: Courtesy of Craftool.* *page 46:* Courtesy of Art Students League, New York. Student in Nathaniel Kaz class. *pages 52, 53 left:* Courtesy of Art Students League, New York. *page 53 right:* Courtesy of Art Students League, New York. Julia Severance, artist. *pages 54, 55:* Courtesy of Art Students League, New York. *page 56:* Courtesy of Art Students League, New York. Nathaniel Kaz class. Bernard Dentan, artist. *page 57:* Courtesy of Art Students League, New York. DeCreeft class. Betty Moller, artist. *pages 62-69, 71:* Courtesy of Art Students League, New York. *page 73:* Courtesy of Whitney Museum of American Art, New York. *page 77 left:* Courtesy of Carlebach Gallery, Inc. Photograph by O. E. Nelson. *pages 77 right, 78:* Courtesy of Carlebach Gallery, Inc. *pages 80-81:* Courtesy of The Art Foundry. Photograph by O. E. Nelson. *pages 82-85 top:* Courtesy of Craftool. *page 86:* Courtesy of Art Students League, New York. Ellen Ross, artist. Photograph by Barbara Carpenter. *pages 88-90:* Photographs by Werner Muckenhirn. *page 91:* Courtesy of the Metropolitan Museum of Art, New York. Gift of J. Pierpont Morgan, 1917. *page 92:* Courtesy of Whitney Museum of American Art, New York. Raoul Hague, artist. Photograph by Geoffrey Clements. *pages 95-97:* Courtesy of The Art Foundry. *pages 98-100:* Courtesy of Harvey Fite. *pages 106-107:* Courtesy of Connie, Bangkok. *pages 108-113:* Courtesy of The Corcoran Gallery of Art, Washington, D.C. *page 111:* Courtesy of French Embassy Press and Information Division. *page 114:* Courtesy of The Metropolitan Museum of Art, New York. Rogers Fund, 1926. *page 115:* Courtesy of The Metropolitan Museum of Art, New York. Fletcher Fund, 1952. *page 117:* Courtesy of Craftool. *page 118:* Courtesy of Kurt Enoch, Vermont Marble. *page 120:* Photographs by Werner Muckenhirn. *page 122:* Collection of Evan Frankel. Photograph courtesy of Jeremiah W. Rus-

sell. *page 123:* Courtesy of Art Students League, New York. DeCreeft class. Andrew Charchenko, artist. *page 124 left:* Courtesy of Art Students League, New York. Havannes class. John Torres, artist. *right:* Courtesy of Alfeo Foggi. Photograph by M. Vukovic. *page 125:* Courtesy of Art Students League, New York. *page 126:* Courtesy of Tomas Penning. *page 129 left:* Courtesy of Jimmy Thomson. *center and right:* Courtesy of The Freda Schaeffer Gallery. *page 130:* Courtesy of Harvey Fite. *page 136-137:* Photographs by Jack Weisberg. *page 138:* Courtesy of Edward Chavez. Photograph by Creative Photographers. *page 139:* Courtesy of Whitney Museum of American Art, New York. *pages 140-141:* Courtesy of Whitney Museum of American Art, New York. Gift of the Howard and Jean Lipman Foundation, Inc. Photographs by Geoffrey Clements. *page 142:* Courtesy of Mrs. Fernand Leval. Photograph by David Farrell. *page 143:* Courtesy of Mrs. Fernand Leval. Photograph by Bullaty-Lomeo. *page 144 left:* Courtesy of Mrs. Fernand Leval. Photograph by David Farrell. *right:* Courtesy of Whitney Museum of American Art, New York. Photograph by Charles Uht. *pages 145, 147 top:* Courtesy of Whitney Museum of American Art, New York. Photograph by Geoffrey Clements. *page 147 bottom:* Courtesy of Jack Weisberg. *page 149:* Courtesy of Whitney Museum of American Art. Photograph by Geoffrey Clements. *page 150:* Courtesy of John McClellan. *page 153:* Courtesy of The Metropolitan Museum of Art, New York. Fletcher Fund, 1956. *page 154 top:* Courtesy of John McClellan. *bottom:* Courtesy of John Bogin. *page 156:* Photographs by Milton Wagenfohrs. *page 158 left:* Courtesy of Pace Gallery, New York. *right:* Courtesy of Pace Gallery, New York. Photographs by Ferdinand Boesch. *page 163:* Courtesy of The Freda Schaeffer Gallery. *page 164:* Photograph by Jeremiah W. Russell. *page 169:* Photographs by Werner Muckenhirn. *page 171:* Photograph by Jeremiah W. Russell.